# Sunlight & Shadows
## in watercolour

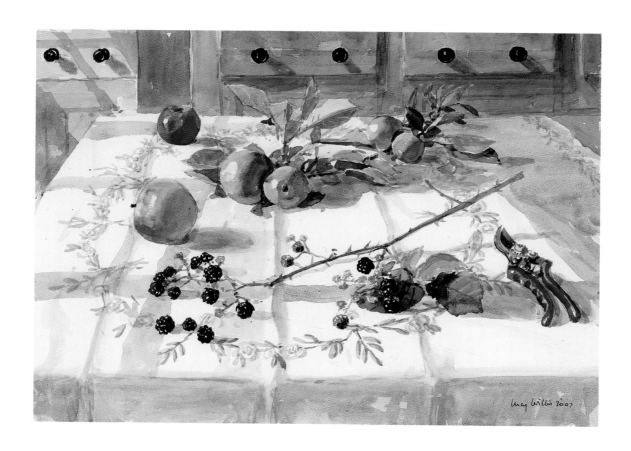

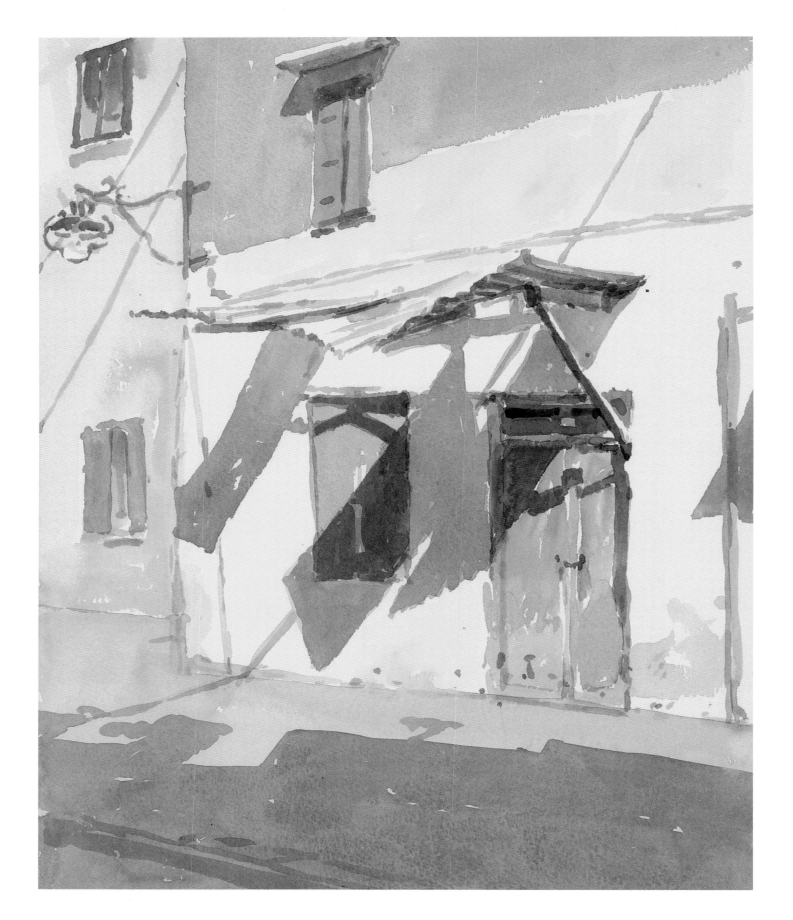

Lucy Willis

# Sunlight & Shadows
## in watercolour

BATSFORD

**For Charlie and Sarah**

First published in the United Kingdom in 2015 by
Batsford
1 Gower Street
London
WC1E 6HD

An imprint of Pavilion Books Group Ltd

ISBN: 9781849942645

A CIP catalogue record for this book is available from the British Library.

10 9 8 7 6 5 4 3 2 1

Repro by Colourdepth, UK
Printed by Toppan Leefung Printing Ltd, China

This book can be ordered direct from the publisher at the website:
www.pavilionbooks.com, or try your local bookshop.

Artist's website:
www.lucywillis.com

Author acknowledgements:
Thank you to Lucy Smith at Pavilion Books for her patient attention to detail whilst editing the book; to my husband,
Tony Anderson, whose writer's skill has helped me explain pictures in words; to Jill Hutchings for continuing to show
my work at the Curwen Gallery, London.

*Page 1: Blackberries and Apples* 41 x 56 cm (16 x 22 in).

*Page 2: Cretan Shadows, Greece* 38 x 28 cm (15 x 11 in)

# Contents

# Introduction

As I was hunting for examples of early shadow drawings to include in this book, I realized that I have been painting in watercolour for 40 years. I left art school in 1975 and although I have continued to work with the other media in which I was trained – oil painting, drawing and printmaking – it was then that I started to experiment with watercolour.

This was also a time in my life when I had started travelling abroad to paint. In 1973, as a student, I made my first trip to the Greek islands and took with me not watercolours but a large canvas bag of oil painting equipment. I loved the experience of painting abroad, soaking up the new visual stimuli, but the resulting oil paintings were a problem. I couldn't pack them up and move on to the next island before they were dry, some pictures became stuck together and I didn't know what to do with the remaining blobs of paint on my makeshift palette. But in spite of this, as a little oil painting from

*North Curry Churchyard, England*

36 x 56 cm (14¼ x 22 in)
The patterns cast by shadows on the ground are as important in this painting as the tree, the buildings and the leaves in the foreground.

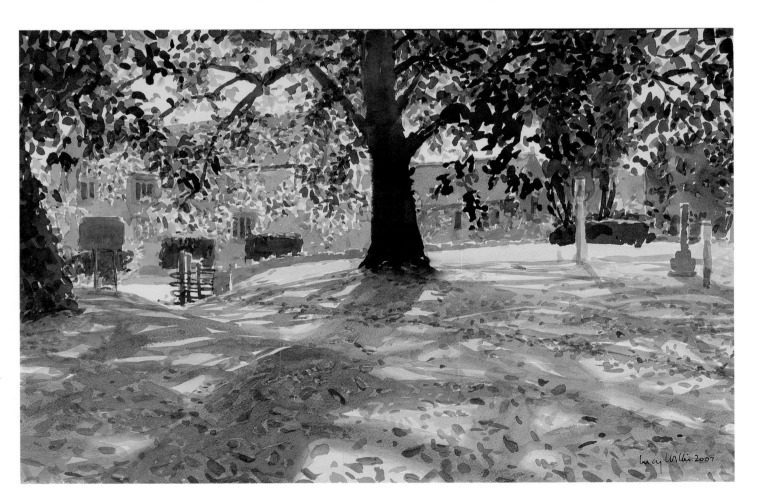

that first trip shows (below), I was already interested in trying to pin down the sunlight and shadows. It was only when I went to live in Greece in 1976 that I started to use my watercolours in earnest to express this interest.

In the years that followed, both at home in England and on trips abroad, I developed my own particular technique, never having been taught watercolour by anyone else. It is this technique that I shall attempt to explain so that, with practice and experimentation, you can use it as a guide to developing your own distinctive style.

It was probably the pragmatic reasons – the ease with which I could carry my watercolour equipment, the speed at which I could work on a painting and then pack it away – that determined my choice of the medium that eventually took centre stage for me. I have loved the way that watercolour works: its special qualities of versatility, its strength and its subtlety and the way, after 40 years, I still discover new things each time I paint.

*The Abandoned Villa, Syros, Greece*

*Oil on paper* 35 x 45 cm (13¾ x 17¾ in)

When I recently unearthed this oil painting from 1973 I was surprised to see that I was as keen then to capture the effects of sunlight and shadows as I am today.

One intriguing aspect of shadows, particularly those cast by strong sun, is that they impose striking patterns onto our familiar world. It seems that our brains have evolved to deal with this and we think nothing of it. Only when you come to paint the effect that light has on our surroundings do you realise how extreme and complicated the changes are when the sun comes out. I still take delight in analysing these changes and making visual order out of the apparent chaos of shadows.

The pictures in this book were painted around my home in England and on my travels to other countries. In 1990, after the publication of my first book about painting, I was asked by *The Artist* magazine to take a group on a painting holiday abroad. Since then I have led 15 trips to some widely differing locations. My most recent book, *Travels with Watercolour*, also published by Batsford, includes many of the paintings from those trips, and this book contains a further selection. I have been immensely fortunate to paint in some especially interesting regions of the world: in China as it started opening up to the West, in Syria just before the civil war, and in remote corners of India, Zanzibar and the Yemen.

Yet as I always remind myself, and I hope these pages will show, it's not necessary to go far to paint light and shadows. Whether you are at home or abroad the challenge is the same: it's a matter of seeing and understanding what is before you, and then being able to put on the paint. My explanations and demonstrations in this book will endeavour to show how this can be done.

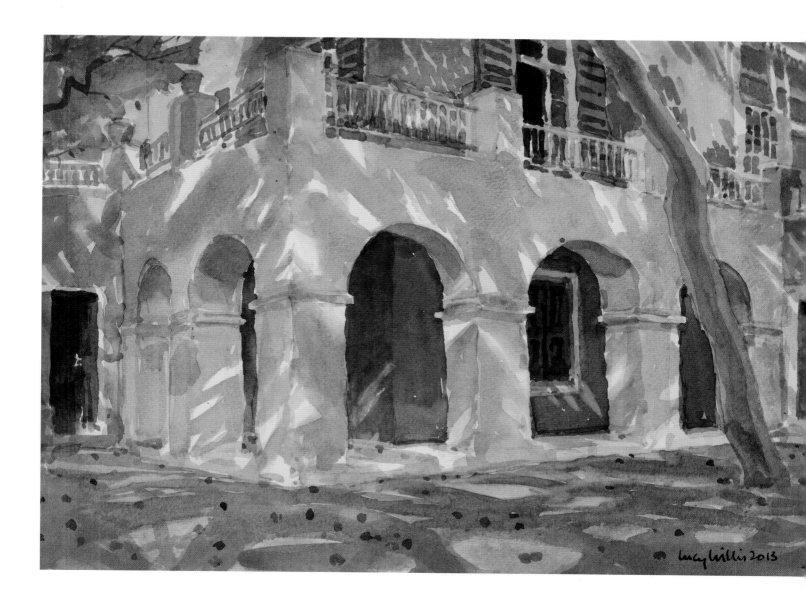

*Morning Shadows, Syros, Greece* 29 x 41 cm (11½ x 16 in)

The attraction for me here was not just the patterns of the architecture but the other more elusive patterns created by the play of the shadows across the structure.

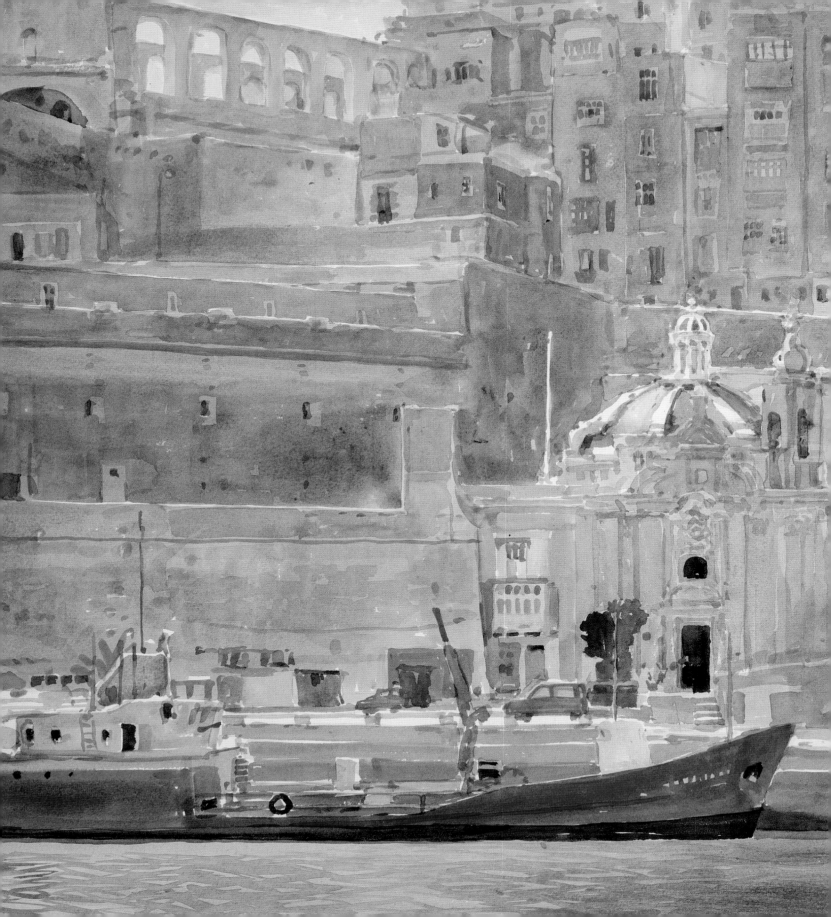

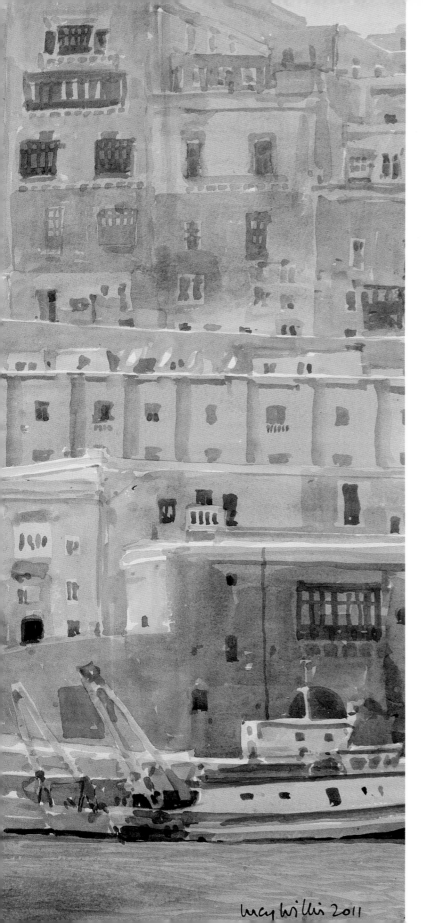

# CHAPTER 1

# Foundations

Both the beauty and the bane of watercolour as a medium is its fluidity and transparency. Making a painting in watercolour is like walking a tightrope and juggling a multitude of balls in the air at the same time. The essential skills you need are mixing colour, adding the right amount of water, achieving depth of tone, organizing the composition, leaving white paper where you want the lightest tones, and all the while controlling the drying of the paint – not too fast, not too slow. And all this is required before even considering the knotty problem of choosing a subject and dealing with the vicissitudes of changing light and shadow!

*The City of Stone, Valletta, Malta*
57 x 76 cm (22½ x 30 in)

# Drawing as the foundation for watercolour

The importance of drawing cannot be over-emphasized when it comes to learning how to use watercolour. When you are attempting a painting, the last thing you want is the necessity to make corrections because you have put something in slightly the wrong place. It is important to maintain freshness in your application of the paint, which you can achieve by applying an area of colour and then letting it settle and dry without disturbing it. You need to be confident and clear from the outset, keeping alterations to a minimum and not overworking your picture by applying too many layers.

Of course, an occasional correction is unavoidable but a firm grounding in drawing technique, well before you put paint to paper, will help to keep them to a minimum. It is the best foundation for starting out as a watercolour painter and essential for training your powers of observation.

I recommend the daily practice of some small drawing exercise – a detail of your surroundings, or simply a cup on a table. Draw your subject with concentrated observation so that each exercise increases your ability to make an accurate rendition. While you probably do not want to paint purely accurate representations of the world around you, this rigour of drawing will give you the option to work in many different ways and the confidence to achieve your aim.

Later, you can try these modest subjects in watercolour, either with or without a pencil line to guide you. Sometimes it is reassuring to draw lightly in pencil on the watercolour paper first so any mistakes are made at the drawing stage before you plunge in with the paint, but if your drawing technique is sufficiently sound you may find you can plot the elements of your composition with a brush and pigment from the outset.

I found that plenty of drawing practice over the course of several years meant that when I took up watercolour I could apply the paint directly without too much risk of mistakes. Over the years this ability has developed with practice so that I can now approach quite complex subjects without preliminary drawing. You can see examples of this method in the first stages of my demonstration paintings throughout the book.

As well as studying line and proportion in your drawing exercises, you will find that tonal studies, which concentrate on light and shade, are immensely useful (see p.28). A lot of practice in pencil, charcoal or pen tonal drawing is good preparation for watercolour because when you come to paint you will find it easier to judge the tonal values in your subject and thus mix the right strength of a particular colour.

## Using perspective

An understanding of perspective is also a key drawing skill. *Coffee in the Khan, Aleppo,* (see p.16) is a painting full of perspective problems: arches, getting smaller as they

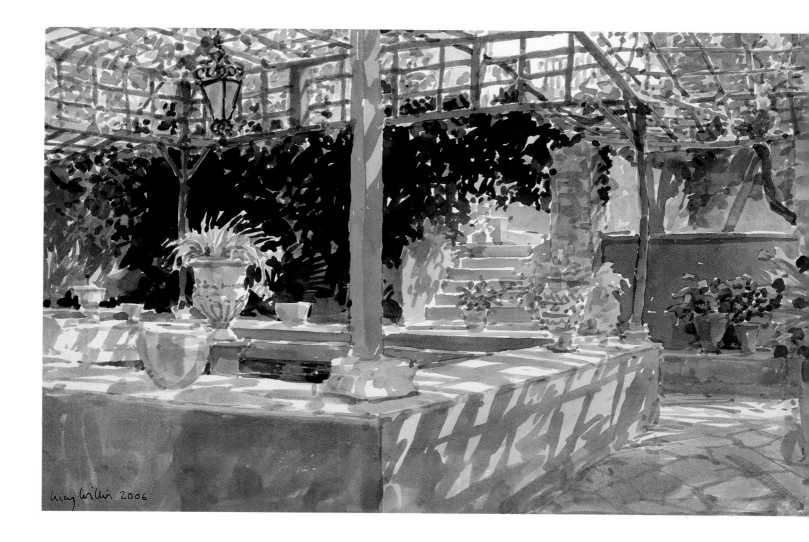

*The Vine Trellis, Episcopio, Greece*

30 x 56 cm (12 x 22 in)

In this painting it is almost as if the shadows themselves are drawing the image and making it three-dimensional, particularly on the top and sides of the low wall where they clearly change direction according to the plane they are falling on.

recede; the distant side of the courtyard seen just above the ornate railings; the angle of the roof planks and the corresponding shadows of the pillars on the floor. Keeping the paint loose meant I could rough in the architectural structure and the figures with blobs and washes at the early stages, only defining them firmly when the elements were all in place to my satisfaction.

While it is far from meticulously accurate, the underlying 'drawing' is sufficiently coherent to give the impression I wanted. I was able to concentrate on the other important aspect of the painting: the sense of being in a cool, shady spot looking out at sunshine which filtered gently through the arcade. By paying close attention to the tones – the lights and the darks – I enhanced the feeling of sunshine outside.

Similarly, *The Vine Trellis, Episcopio* (above) shows how drawing comes into play, not only in creating the complicated composition of trellis slats, pillars, walls and steps, but also in the pattern of sunlight and shadows throughout the painting.

# Demonstration: Patsy's Garden, England

Drawing with my brush, I usually start a painting with a pale, neutral colour (often the dregs of colours left in my palette from the last time it was used) and make small dots and dashes to indicate where things will go. I try not to make lines as they would be too noticeable if I needed to move their position. This approach leaves me with the option to change things slightly at the early stages without making too much of a mess. The marks are incorporated into the final painting as part of the general texture.

**Step 1**

One of the essential things to plot in an initial drawing – as important as a house, a tree or a flowerbed – is the position of the shadows. Knowing that the sun would swing round before I had finished painting this scene, I marked them in early. The shadows of the tree trunk and trellis posts and the slanting shadow on the roof were all put in with a mix of Cerulean Blue and Winsor Violet. It is these shadows, along with the others that would be fleshed out later, that ultimately give the impression of sunshine in the garden. I also blocked in the window shapes. Although the window frames were white, they appeared blue-grey in shadow.

**Step 2**

Another essential element in capturing the effect of sun in a garden is to contrast the foliage that has sun shining through it with that which is in shadow. My first marks included a few of the translucent leaves hanging from the tree. For these I made a vibrant yellow-green mix of Lemon Yellow and a tiny touch of Sap Green. As the second stage progressed I added more and more of these leaves and contrasted them with the dark blue-green leaves on the right. Now that the pale window shapes were dry I could over-paint them with the darker window panes. I then surrounded them with a basic pink for the brick walls made of Yellow Ochre, Cadmium Red and a touch of Winsor Violet.

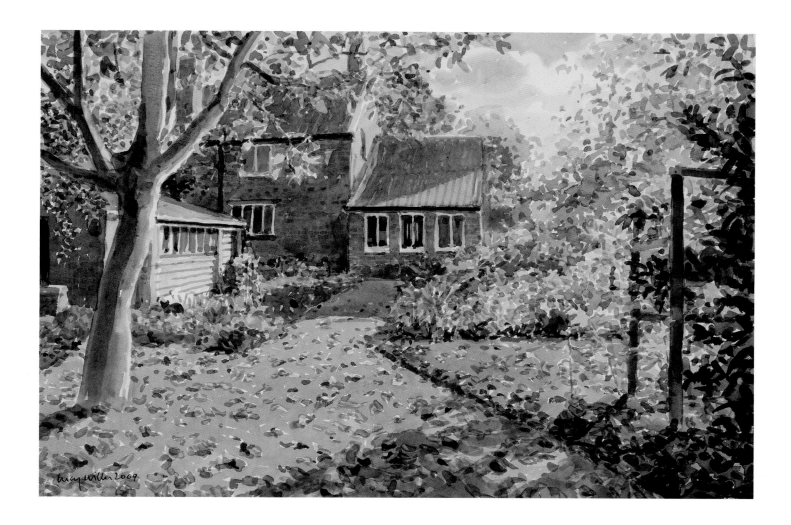

### Step 3

*Patsy's Garden, England*

30 x 56 cm (12 x 22 in)

Gradually I built up the details, filling spaces until most were accounted for. I painted leaves on the ground with quick little strokes in a variety of colours and then interwove a green grass colour (Lemon Yellow again but with more Sap Green), making sure I did not paint over the leaves if I could avoid it. I filled in the brick wall on the left side, taking care to leave a broken patch for the hanging foliage and berries. I put a second wash of colour (Alizarin Crimson, Yellow Ochre and Winsor Violet) on the main house and started to paint a suggestion of brick texture on the right extension in a very pale version of that mix. Finally I deepened many of the tones to enhance the sense of sunshine and shadow. I put a second wash on the green of the shadow on the grassy path to darken it and added details to the house, defining bricks and roof tiles. On the right I deepened still further the dark green foliage with a strong mix of Sap Green and Winsor Violet, which really highlighted the transparent leaves beyond.

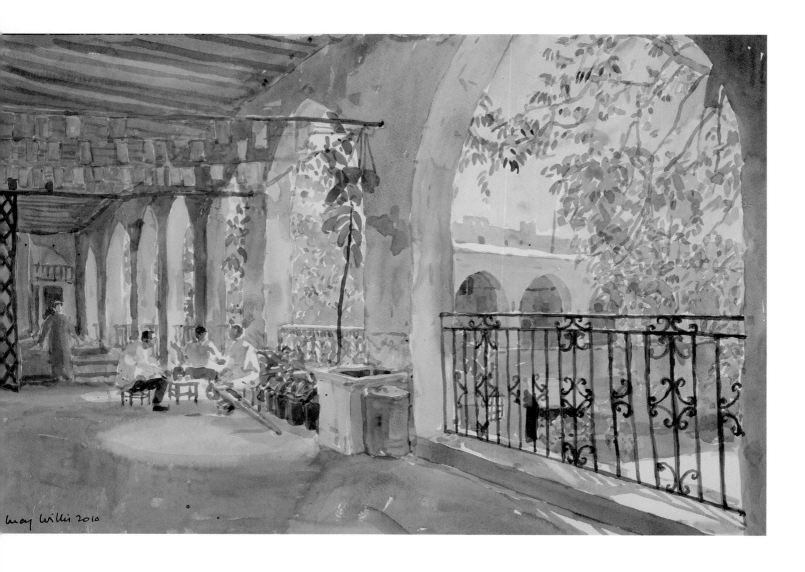

*Coffee in the Khan, Aleppo, Syria*

39 x 60 cm (15½ x 23½ in)

Often, when painting abroad with constraints of time and place, I paint as much of the picture as I can in the time available. I then pack up before I have a proper chance to assess what I have done. At home after returning from Syria I was able to stand back from this painting and see where I needed to add extra darks to pull the composition into focus and where my perspective might need slight adjustments to make the spaces work. All this can be done with careful over-painting.

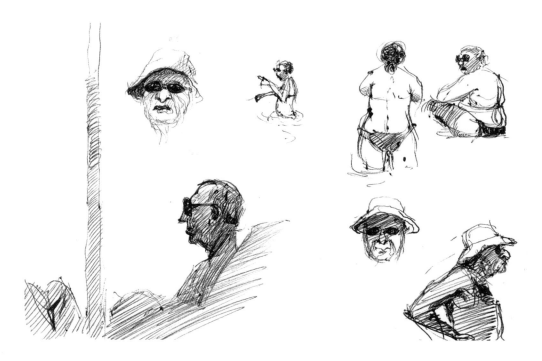

# Keeping a sketchbook

I have kept a sketchbook ever since my schooldays. It is an immensely valuable way of recording what you see, whether you are drawing for its own sake or gathering aides-memoires for paintings. It is also a good way of keeping your hand in when you are not painting for a period of time. In the early days I would draw anything and everything; now I carry my little book mainly to record figures in various locations – a beach, a town, an airport or a station, for example. My sketchbooks supply me with a fund of studies, which I can either turn into small paintings later, or delve into if I need to add figures, animals or other details to a larger painting.

The sketches are also a way of recording details of light and shade. Sometimes I represent the tone of shadows by cross-hatching, as in *Komito* (above), and at other times I make written notes to save time, as in the sketch for *Conversation by the Sea* (see p.19). I draw with either a pencil or a pen – sometimes a water-soluble pen which can yield a wash of tone quickly with a smudge of spit on the finger (see p.20).

After a journey abroad I often turn the quick sketches I did there into paintings in the studio. *Marina Beach, Chennai* (see p.18), is a triptych of small watercolours that I painted from drawings in my sketchbook a year after my return from a trip to India.

*Cousins in Blue, Plaiting* (see page 21), was also done on my return from my travels. My drawing provided the composition and written sketchbook notes gave a few details of colour and tone on the figures. But it was my memory that supplied the shade: we were all sitting under the boughs of a large tree.

*Komito, Greece*

I have always enjoyed observing people and sketching them when a particular character or pose catches my eye. The shadows on the figures here are as important as details of shape and size and I use hatching to achieve the tones, working with a ballpoint pen in a small sketchbook.

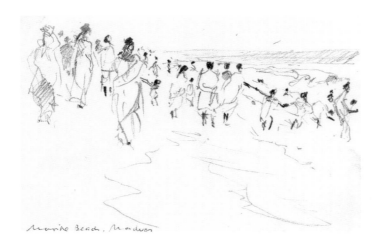

*Marina Beach, Chennai, India ( pencil sketch, looking left)*

15 x 20 cm (6 x 8 in)

This is one of the three rapid sketches I made from which I later painted the triptych below. Here, I am looking to my left with the sea to my right.

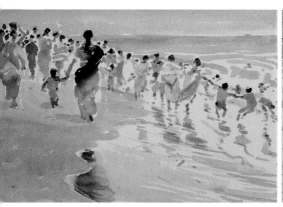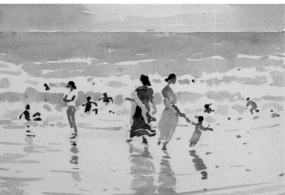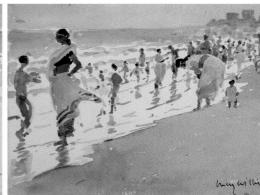

*Marina Beach, Chennai, India*

20 x 28 cm (8 x 11 in)

I was fascinated by the crowd of families on the steeply shelving beach and sat among them, drawing their positions in relation to the sea, their stances and their clothing. I first sketched looking towards the left along the crowded sea-shore then turned around to sketch the scene to my right. Later, looking through the sketchbook, I found I had very quick sketches with figures from both sides, almost in mirror image, so I invented a middle section, looking directly out to sea, to bridge the gap and complete the triptych.

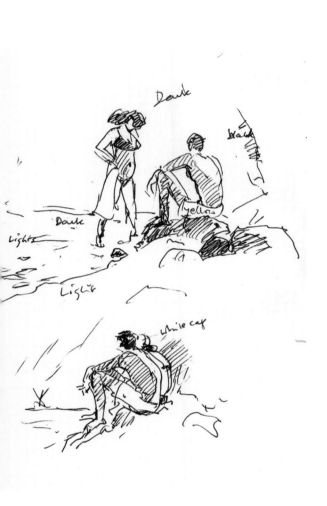

*Conversation by the Sea, Greece (sketches)*
I drew in an A5 sketchbook with a black ballpoint pen. I made notes so that I could remember the basic tones without the necessity for lots of shading, but the drawings were mainly to catch the pose of the figures. It was the top study that I decided to turn into a little painting.

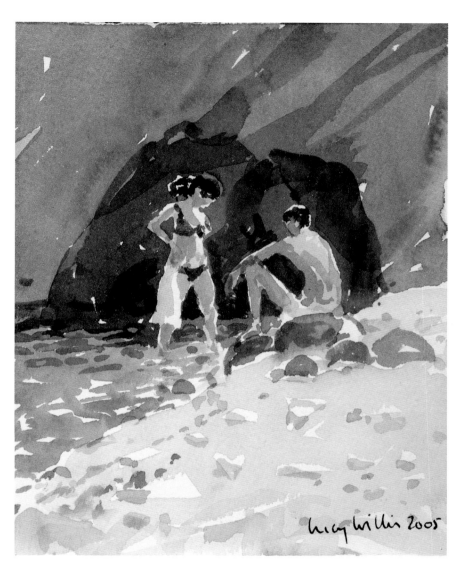

*Conversation by the Sea, Greece* 20 x 15 cm (8 x 6 in)
This painting was done in the studio. With the help of my notes I was able to remember the way that the figures stood light against the dark rocks and the light pebbles littered the shore in the foreground.

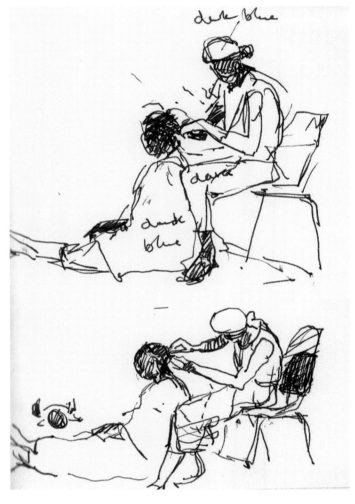

*Sketchbook page*

12½ x 10 cm (5 x 4 in)

I often sketch when I'm on the move and have an endless supply of tiny figures drawn from the upper decks of London buses. Here I have used a water-soluble pen, smudged with a licked finger in places to make the shadows.

*Cousins in Blue, Plaiting, Senegal (sketch)*

10.5 x 15 cm (4¼ x 6 in)

This sketchbook page is tiny but I often carry a book this size. It will fit in my pocket and can be used discreetly so people may not notice they are being drawn. I made the painting (right) on a larger piece of watercolour paper measuring 18 x 28 cm (7 x 11 in).

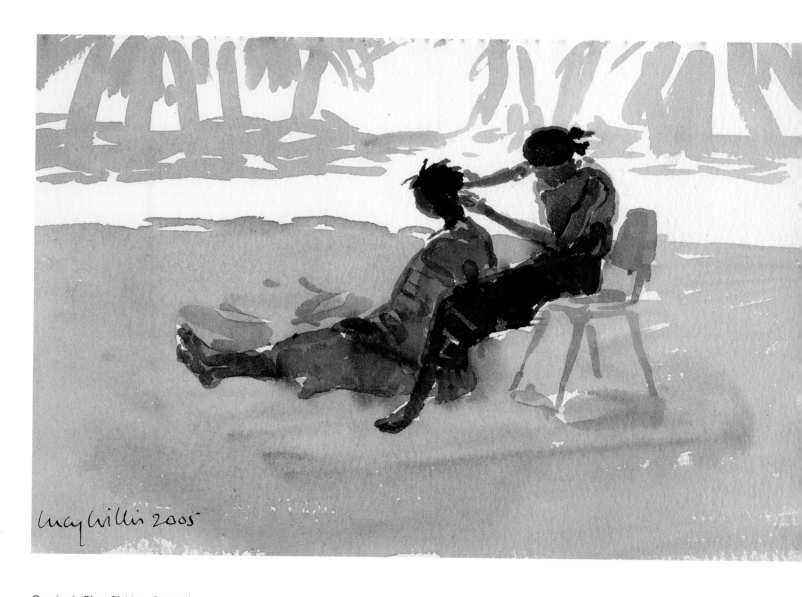

*Cousins in Blue, Plaiting, Senegal*

18 x 28 cm (7 x 11 in)

Leaving the white of the paper in a horizontal band beyond the figures, I tried to create a strong sense of sunshine and heat by laying on a grey wash in the entire foreground and then adding simplified, monotone shapes at the top of the painting in the same shadow colour to suggest the palm trees beyond.

# Photographs as a starting point

I am careful not to become too reliant on painting from photographs as I find the process of working from life so invigorating. Working in the studio from a photograph in controlled conditions is a very different process to working on location but I try to make decisions and select priorities in the same way, and with the same sense of speed and urgency, as I would if I were in front of the subject.

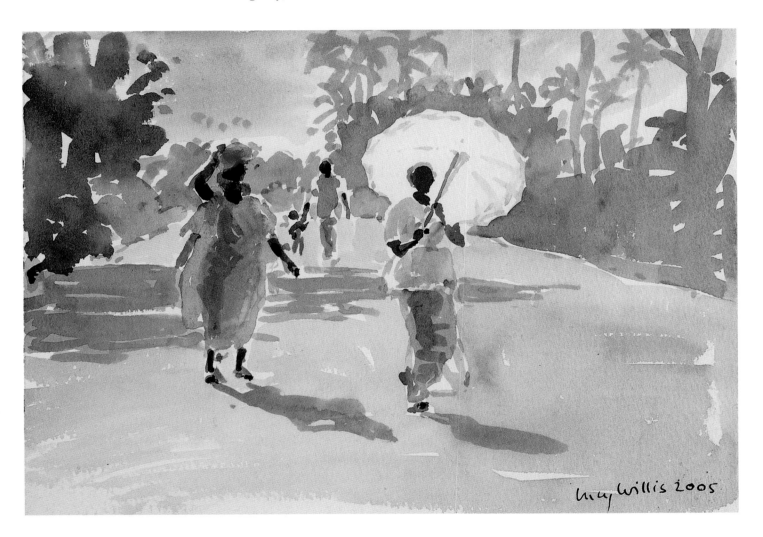

***The Road to the Sea, Senegal*** 20 x 27 cm (8 x 10½ in)

Delighted by the sunlight shining through the umbrella, I just managed to take a photograph of these people as they walked towards me. Back at home I could translate the image into a small painting, keeping the handling loose and simplified, much as I would have done had I been working on the spot.

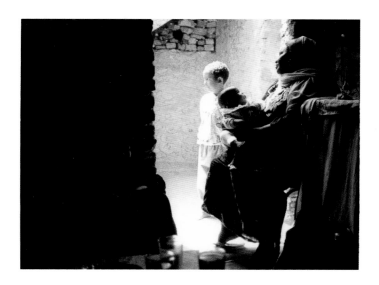

*The Mother-in-law (photo)*

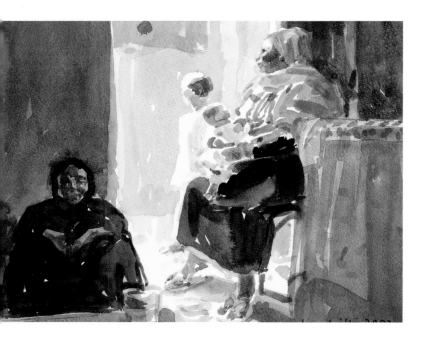

*The Mother-in-law, Aswan, Egypt* 20 x 24 cm (8 x 9½ in)
I was unable to paint during my fleeting visit to this family but, with permission, I took a photograph. The left-hand figure is almost completely lost in the dark but I remembered how she had looked so I was able to paint her in more detail than the photograph yielded.

There is no doubt that the use of photography has widened the range of possibilities for artists by enabling them to capture a fleeting glimpse of something they might want to paint. Presented with a subject that would take hours of work and no time in which to do it, the artist can simply take a photograph that can be used at a later date for reference and to prompt memories of the scene. This was the case for me with both *The Mother-in-law, Aswan* (below, left)and *The Road to the Sea* (opposite), when time and place did not permit me to get out my paints.

Similarly for *The City of Stone, Valletta* (see p.11) I took a single photograph of the scene as I passed the city on a boat. Later I studied the photograph and was fascinated by the architectural detail, the subtle variations in colour and light and the way the terraced buildings filled the whole frame.

It was an ideal subject for a studio painting and I chose a full imperial sheet of Waterford Saunders 300gsm Cold-pressed (NOT) (57 x 76 cm/22½ in x 30 in). I printed the digital photograph on a piece of A4 office paper and roughly squared it up by laying a cellophane sleeve marked with a grid of black-marker squares over it. I drew a larger grid lightly in pencil on my paper to correspond to each square on the cellophane and transferred the rough scheme of the composition to each square using dots and dabs of colour.

When each square was roughly accounted for I erased the pencil lines and continued to paint each building, bit by bit, taking care to leave tiny areas of white highlight. Later I added windows, doors and architectural details on top of the dry under-washes of Yellow Ochre and shadow colours. I didn't peer too closely at the photograph and overwork the details – instead I tried to imagine I was working on the spot, rushing to beat the changing light, in order to keep the painting fresh and spontaneous.

# Demonstration: Reflections, Venice

This picture of a Venetian canal was painted in my studio in England. I had been struck by the scene and the clarity of the reflection so had taken a photograph for reference for a painting. The fact I had a static image to work from was immeasurably helpful when it came to unravelling the complexities of shadows, oscillating surfaces and the reflected architectural image.

**Step 1**

I made marks in blues and greys to start with, keeping them loose and dilute so that I could make adjustments as I went along if necessary. As I started to place some major shapes I first laid a heavier tone where the right-hand building in shadow was reflected on the water.

**Step 2**

I gradually filled in the dark shapes until the bright reflected building was the main light element, left as white paper. When the grey wash on the left boat was thoroughly dry I painted the stripes on top. I laid areas of pink wall colour above this, which I also needed to let dry before I could apply the suggestion of brick pattern in a richer colour at the next stage.

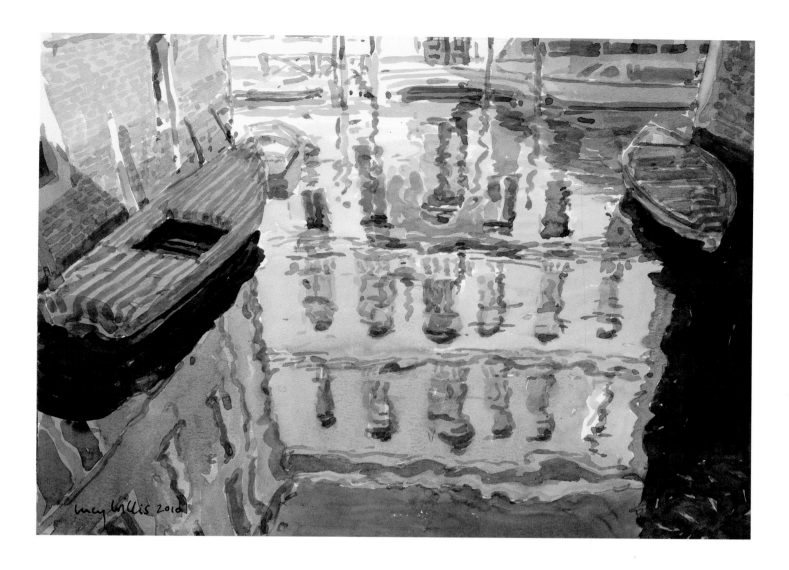

## Step 3

The shadows on the boats and side walls are the key to the sense of sunlight across the water and in the reflection of the sunlit building. The darkest reflections are applied with a mixture of Prussian Blue and Alizarin Crimson making an almost black hue. I work quickly and often leave chinks of white in a dark wash from the rapid brush-strokes. Here I have made use of them at the final stage, to paint bright orange fallen leaves floating on the surface of the water.

# Shadows

In everyday parlance and in literature over many centuries, the word 'shadow' has acquired a number of connotations – very often negative ones, such as 'casting a dark shadow'. However, for painters shadows are miraculous things because a shadow in a painting immediately suggests light. Shadows create light by way of contrast.

Early painters omitted the depiction of cast shadows – those thrown by an object onto another surface. It is hard to find a cast shadow in early Egyptian or Byzantine art and indeed shadows did not feature much at all until the thirteenth century, when the Florentine painter Giotto started a quiet revolution. He introduced shading on his figures to suggest three-dimensional volume, and gradually light and shade became part of the artist's repertoire.

Yet for a long time cast shadows were still avoided. Artists' studios in the northern hemisphere were traditionally chosen for their particular north light, so the sun would not shine in on their subject or their canvas and the conditions for painting remained more or less consistent throughout the day.

But while oil painters were closeted in their studios, watercolourists were something of a law unto themselves. In the early days of English watercolour painting, eighteenth century artists would use the medium for making small sketches in the local countryside or on their travels around the world. These paintings were referred to as 'drawings' – sometimes still are – and frequently considered nothing more than a sketch for a grander painting in oils. The advantage of watercolour, then as now, was that the equipment could be carried into the countryside so artists could work directly from nature. Outdoors they could observe the sun in all its glory, and the effect it had on the landscape. Many a watercolour by JMW Turner and his contemporaries has raking shadows which create an atmospheric rural idyll.

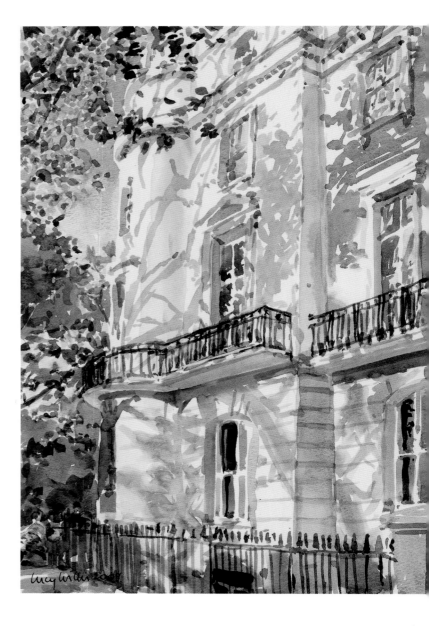

*Number One, The Royal Crescent, London, England*
38 x 28 cm (15 x 11 in)
The inspiration for this painting was the subtle interplay of shadows and the architectural details of the façade of the building.

From an artist's point of view, the nature of a shadow can be found by close study of colour and tone. There are as many permutations of shadows as there are conditions of light: cast shadows, attached shadows where a surface curves away from the light, soft-edged and hard-edged shadows, double shadows (from multiple light sources) and so on.

## Cast shadows as a subject

When I am painting outdoors on a sunny day, I often go for a subject where the shadows form a major part of the scene. If I paint 'contre-jour' (facing the sun or, literally, against the day) the shadows are thrown on the ground towards me, as in *The Stick Gate, Senegal* (see p.28) and *Shadows and Columns, Venice* (see p.29). I really enjoy this effect and make use of it to define the plane of the ground upon which the shadows are falling. It also gives rise to halos of light around objects which are lit from behind, as can be seen in *Burano, Venice* (see p. 123).

A completely different but equally compelling effect of cast shadows is the dappled shade cast by tree foliage. It may be that the shade falls on a building, and it is a real challenge to create the impression of sun filtered through leaves while allowing the architectural features to hold their own against the scattered pattern. This can clearly be seen in *Number One, The Royal Crescent*, where the complications of a steep architectural perspective, reflected light and a chaos of cast shadows all conspire to trip you up. However, making some sort of order out of this kind of visual confusion is a challenge that I relish. To stand back after an hour or two of work and see that the picture is beginning to make sense is very gratifying.

*Plane Tree Shadows, Crete* is a much more straightforward composition. The building is painted face on, there were no perspective worries and I was able to concentrate on the shadow patterns on the wall and the colour variations within them. Where the same shadow pattern falls on the ground the scheme changes from a diagonally slanting one to a more horizontal pattern of lozenges of sunlight.

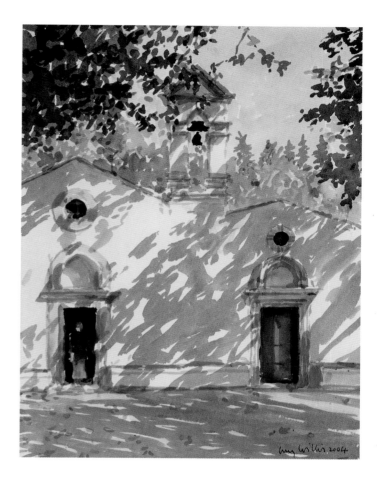

*Plane Tree Shadows, Crete, Greece* 38 x 28 cm (15 x 11 in)
The sun filtering through the branches of the trees throws a striking diagonal pattern of dappled shade onto the church wall and bell tower. I placed the doors and round windows lightly first and then added the shadows, varying my shadow colour as I went along to pick up the subtle changes in hue within the dark tone.

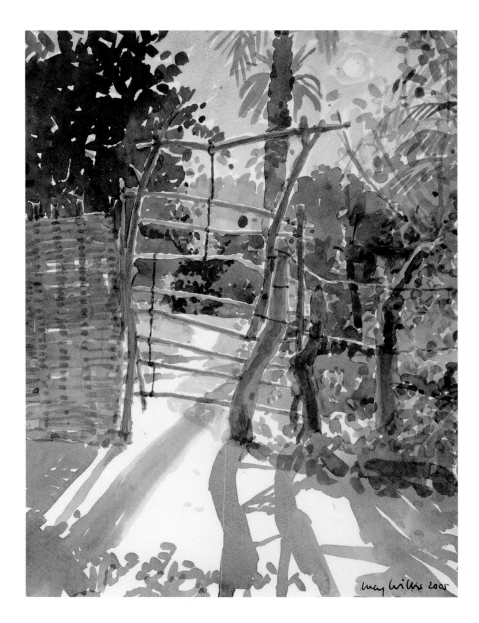

gate in the Cashew avenue

*The Stick Gate, Senegal*
43 x 28 cm (17 x 11 in)
In Senegal I was enchanted by the many imaginative designs of gates made of little more than sticks and string. However, it is the shadow that this particular gate cast on the foreground that prompted me to paint it.

When trying to analyze shadows it often helps to make a tone sketch in pencil or back crayon, as illustrated above. Drawing tonally in monochrome can train the eye to more easily see the shapes of light and dark.

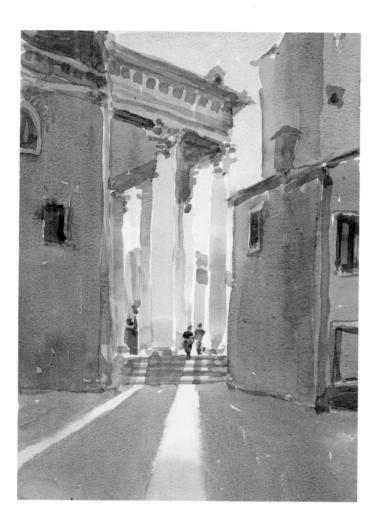

*Shadows and Columns, Venice, Italy*
28 x 18 cm (11 x 7 in)
In this back-street view of a very grand Venetian church it is the shadows that make the composition for me. The chinks of sunlight between the columns and the buildings create shadows that converge at a vanishing point which happens to coincide with the two tiny figures that appeared while I was painting. They help to give scale to the monumental portico.

*Chiesa del Pergatorio, Sicily, Italy*
38 x 28 cm (15 x 11 in)
The shadow of a building to my right afforded me somewhere to sit and paint out of the direct sun. It also created an interesting composition full of dramatic light and shade as well as interesting reflections in the shadow area on the shiny marble foreground.

# Sunlight and shadow patterns

It is impossible to separate patterns of sunlight from shadows, of course. The clear, crisp shadows of the figures in *Walking in Sunlight* (below) would be non-existent without the sunlit areas of the ground. I left the paper entirely white for the path and painted the shadows of the two figures as a single, rather complicated shape. Had the day been overcast these would have been at most soft-edged, darker smudges within a dark ground, if visible at all. But here we have bright sun casting almost photographic projections of the figures onto the horizontal plane on which they walk.

*Walking in Sunlight, Venice, Italy*

33.5 x 28 cm (13 x 11 in)

The shadows of the figures give us a sense of the horizontal surface of the path and the direction of the sun but most of all a feeling of warmth and a balmy atmosphere. I added the shadows to the right of the scene mainly to fill a space and balance the composition. Rather than invent the shadow of a building or a tree, I made them in the shape of figures, people visible only by their shadows, adding an air of mystery.

Whether the edges of a cast shadow appear sharp or blurred depends not only on the light conditions but also on the distance between the object which is casting the shadow and the surface on which it is cast. You will often see soft and sharp shadows within the same scene, where some shadows are cast on to a surface nearby and others are cast from further away. Typically the dappled shade from trees has patches of dark and lozenges of light, both of which have soft edges. If you look closely at *Turkish Fountain, Hania* (right), you will notice that both are present in this painting. Some are cast by close up objects – the palm fronds and the pillars – and others are more soft-edged, such as the dappling on the conical top of the fountain and in the left foreground. These are cast by tree foliage which is further away. Once you become attuned to looking for these variations you will find there are endless permutations on the shadow theme.

A different sort of pattern is created by window bars when you are painting indoors. One of my favourite subjects is the interior of a greenhouse, where the wooden glazing bars are mirrored in a grid-like pattern of shadows and light. *The Greenhouse and Peppers* (see p.32) was painted on a clear sunny day and it was something of a task to sort out the various elements: the shadows on the wall, the window at an angle and the reflections in it, the slope of the roof bars as well as all the different horizontal lines, angled because of the deep perspective.

There was also a multitude of patterns within that structure. I painted a light terracotta wash over most of the brick wall and when it was dry I added the grid of shadows. When I came to paint the brick pattern I had to make sure that the individual bricks on the sunny parts of the wall were pale enough to read as sunshine not shadow, and so keep the strong contrast. The pepper plants are lit up in sunlight and also throw a shadow pattern of their own on the left-hand wall.

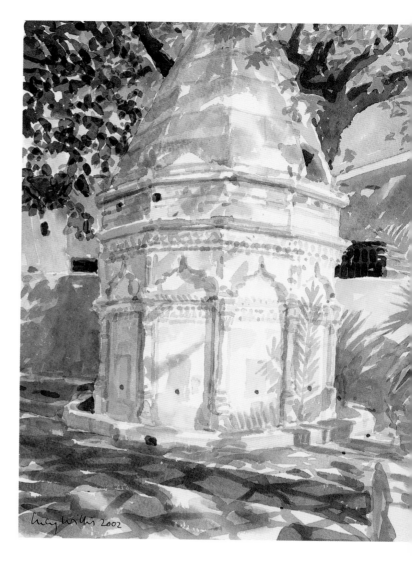

*Turkish Fountain, Hania, Crete, Greece* 38 x 28 cm (15 x 11 in)
I painted the more sharply defined shadows such as the palm fronds, with the point of a brush on to dry paper. When I came to apply the shadow shapes of some of the more distant foliage, I softened the edges with a little clean water to enable the paint to bleed and blur slightly.

# Shadows in perspective

The laws of perspective (where things appear smaller the further away they are) apply to shadows as they do to anything else. You can often observe that the shadows of buildings converge at their own vanishing point, as seen in *Shadows and Columns, Venice* on p.29. I mainly work by eye, placing and checking my lines of perspective by simply holding up my brush to gauge the angle and getting it clear in my mind before committing it to paint.

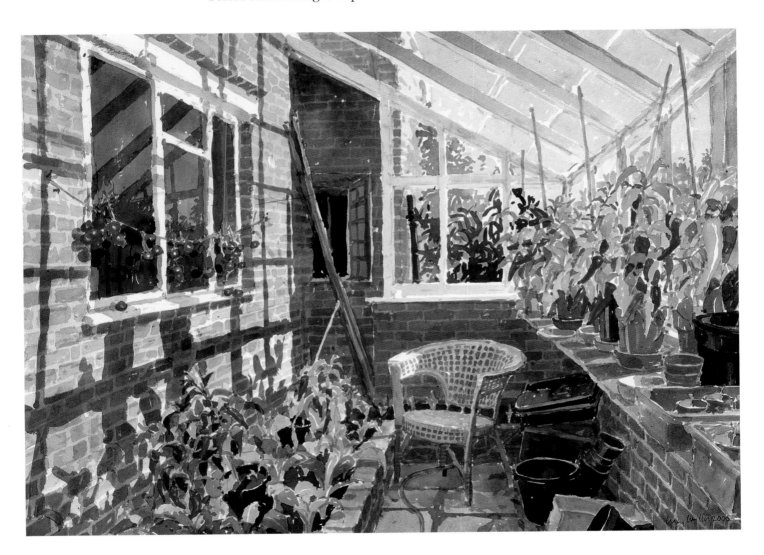

*The Greenhouse and Peppers, England* 57 x 76 cm (22½ x 30 in)
The grid of shadows on the left here form an important part of the composition. They follow the same laws of perspective as the glazing bars that cast them.

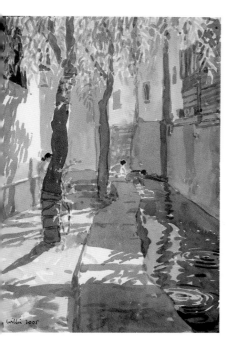

*The Stream, Lijiang, China*
38 x 28 cm (15 x 11 in)
The patterns of light and shadow on the path and left-hand wall are key to defining the various planes in this narrow alleyway. This scene on an overcast day would have had a very different impact.

*Under Tamarisks by the Sea, Greece*
18 x 28 cm (7 x 11 in)
To represent this tangled shadow pattern I started on the left, using a strong mixture of Cobalt Blue and Winsor Violet and changing occasionally to a brown mixed from Cadmium Red and Yellow Ochre, applied wet-into-wet. I tried to apply the whole shadow pattern in one more or less seamless process.

Notice how the shadows in *The Greenhouse and Peppers* conform to the same laws of perspective as everything else in the picture: all the receding horizontal lines which are parallel – whether glazing bars, shelves, flowerbed edges or window frame – meet at a vanishing point somewhere in the centre of the picture, level with my eye-line. The shadows on the wall also represent horizontal lines, projected by the glazing bars opposite, so they get narrower as they recede and they too meet at the same vanishing point.

Back in the studio it sometimes helps to take a piece of string when the painting is nearly finished and pin it to the vanishing point (where two of your converging lines meet at your eye level). You can then pull the string tight and hold it against all the various lines that should meet at the same point. If any are significantly out you can, at this stage, make a tweak here and there until it looks convincing. Strict accuracy is not always necessary, but if something looks unsettling this is a way of checking.

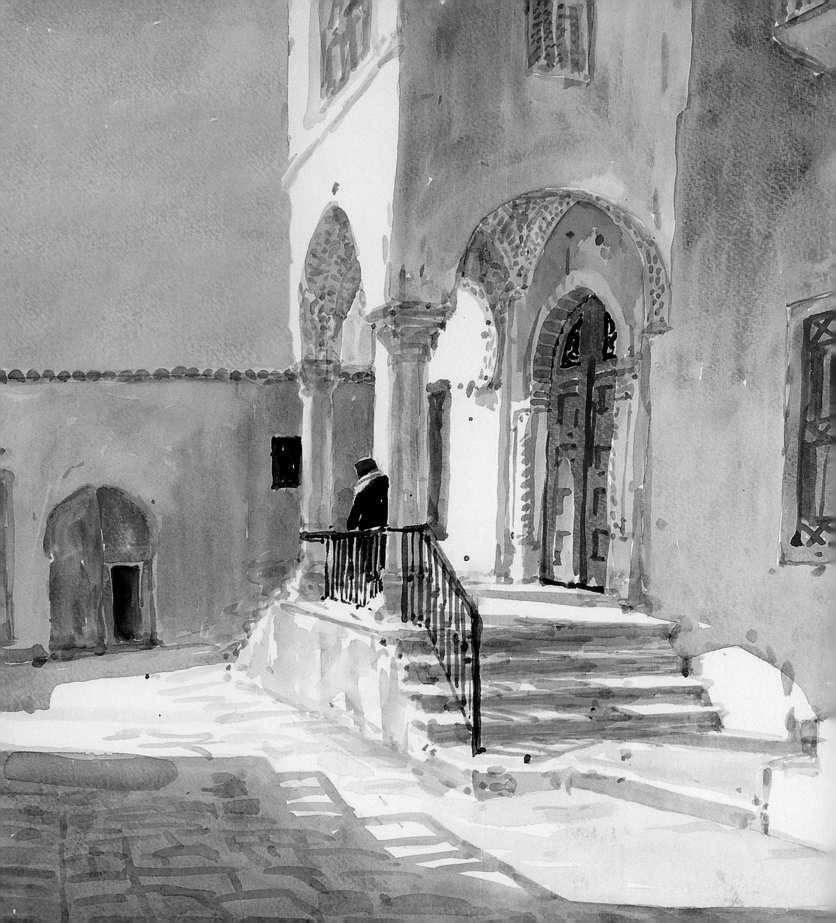

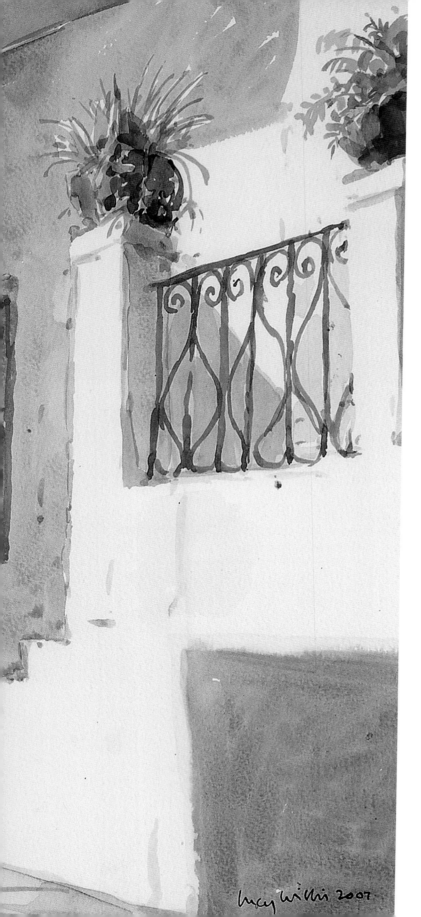

# Equipment

I have used the same selection of watercolour equipment for many years now and my advice is always the same: even if you are just starting out, try to invest in the best artist's quality paints, brushes and paper. Watercolour is the most economical painting medium and requires a surprisingly small amount of equipment. Your supplies will last a long time if you are working on small to medium-sized paintings, so do not be afraid to squander paint and paper occasionally in the name of experimentation. A bit of wastage is worth it if it helps to you loosen up and master the technique.

*Sidi Bou Said, Tunisia*
42 x 60 cm (16½ x 23½ in)

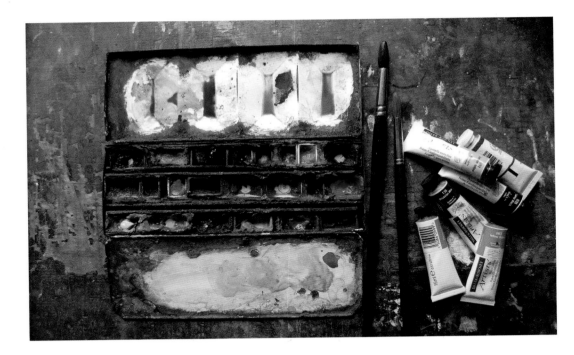

*My paintbox and brushes*

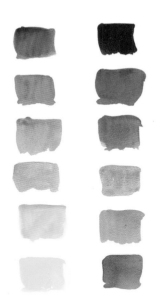

*Colours from my paintbox*
Top to bottom, left:
Warm colours.
Winsor Violet, Alizarin Crimson,
Cadmium Red, Yellow Ochre,
Cadmium Yellow, Lemon Yellow.

Top to bottom, right:
Cool colours.
Ivory Black, Prussian Blue,
Cobalt Blue, Cerulean Blue,
Cobalt Turquoise, Sap Green.

# Paints, brushes and surfaces

Here I shall describe my own equipment, both for painting on location and also the additional bits and pieces which I have back in the studio. When I am travelling I like to be able to carry all my equipment with ease so I can walk long distances or get on and off a bus with it. Of course you will develop your own store of materials as you discover what suits you best, but what follows is a good working selection for me.

## Paints

I use a battered enamel paintbox which originally held pans (blocks) of colour. Now I replenish the little pan containers from tubes of artist's watercolours which I buy in larger quantities. If you are just starting out you could try the palette I mention, left, to start with and gradually try new colours as your experience widens. Or you can choose your own selection of colours, including at least two of each of the primary colours: two reds, two blues and two yellows. You can mix a vast range of both strong and subtle colours from these. I also include a purple and a green as well as black. I do not include a white watercolour in my selection as I prefer to use the white of paper and translucency of the paint to make light colours. But I do have a little pot of white gouache paint, known as 'body colour', for making corrections as I have done in *Valletta Arcade* (see p.41). If you are unable to wash out all the pigment from a part of the picture you want to return to white paper, white body colour will cover it. Use it sparingly, though, as it will affect the way the watercolour settles on the paper when you paint over it.

## Brushes

I always buy round sable brushes; there are some very good substitutes but I like the way a good sable will go on and on holding its point. Even when it is worn and rounded it can still be useful for broader strokes. I have one large size 10 brush with a long handle, about 27 cm (10½ in) long in all, and a smaller size 8 sable about 23 cm (9 in) long. I usually carry these with me, putting them in a stiff sleeve so that the hairs do not get bent in transit. At home I have a range of other brushes – a size 14 sable for bigger washes and all sorts of old, worn brushes that can be called into service from time to time.

## Paper and board

I use papers of varying weights but often 190–200gsm for small to medium-sized paintings and 300gsm for large ones. A thinnner paper will tend to cockle under wet washes and I prefer not to stretch my paper before painting as this takes times (wetting it and sticking it to a board with gummed tape, then leaving it to dry). I mostly use Bockingford Paper or Saunders Waterford 100 per cent cotton mould made rag paper, usually with a fairly rough CP (NOT) surface and always acid free so it will not discolour with age. I also use handmade rag papers from time to time.

In the studio I can work on full-sized sheets (approx. 56 x 76 cm/22 x 30 in) but for outdoor painting I cut up full sheets and take a selection of sizes. Even quite small offcuts can be useful. I always carry a few long pieces of paper trimmed from larger sizes to use for quick little studies like *Valletta Skyline* (see p.39). If I am planning to work on paper any bigger than that which I can carry in a large, stiff envelope, I put my paper in a portfolio measuring 47 x 64 cm (18½ x 25 in) which will double as a painting board when I sit down.

When I am painting watercolours at home and in the studio I use a drawing board to support my paper. I usually rest it at an angle against a table and hold my paper by resting the bottom edge on two drawing pins pushed halfway into the wood.

## Camera

My camera has become an important tool in my kit, enabling me to paint pictures of scenes where I have had no time to linger (see pp.22–25). I use a basic digital camera and download the photographs when I get home. I can then print them out as required at a size up to A4 and choose how to use the images, or parts of them, in my paintings. I am not a skilled photographer, so night scenes and dark interiors still have to be drawn rather than photographed for reference.

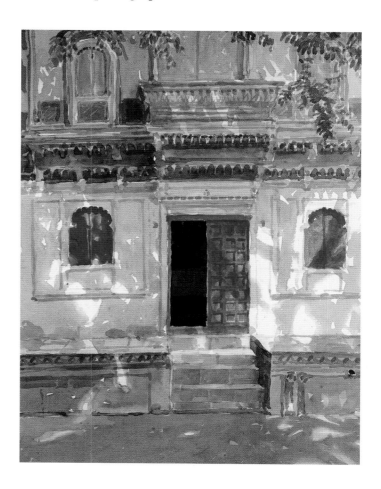

*Dappled Shade, Jaisalmer, India* 58 x 44 cm (23 x 17½ in)
Many of my colours are started by mixing fresh colour into the paint that is already on my paintbox palette. I add a little more of one colour or another – to make a grey, as in the foreground here, a soft green as in the foliage or a range of dull yellows and browns, so nothing is wasted.

# Drawing materials and accessories

I have sketchbooks of varying sizes: tiny ones to go in my handbag, larger ones to fit in my rucksack and, for use at home, large sketchbooks and loose sheets of paper. I draw with pencils, ballpoint pens or water-soluble ink pens in my sketchbooks. At home, where I can also use a fixative, I have different sizes of charcoal. I often use this on its own but sometimes combine it with watercolour.

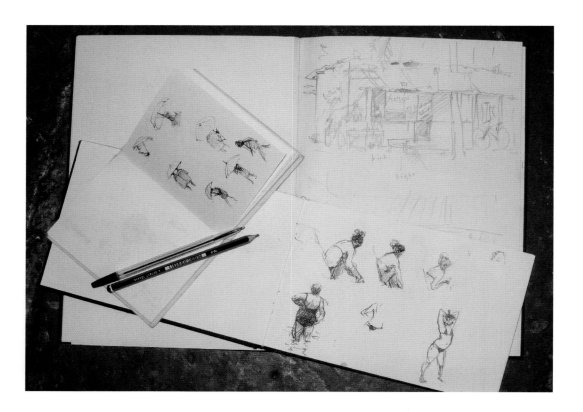

Any container can suffice for water at home, but if you have to carry water to your painting spot, a small, wide-mouthed plastic pot with a screwtop is best. Although I very rarely change my water during the course of a painting it is important to have some extra water in case of spills or other problems, so I take a small bottle of water as well.

For travelling, I also carry in my rucksack a tiny folding stool, an inflatable cushion to make it more comfortable for long periods of sitting, and a folding hat. The hat is essential when you are painting sunlight because it shades your eyes from the bright sky. While painting *Sidi Bou Said* (see p.34) I wore a hat even though I was sitting in the shade to reduce the glare.

In the studio I have an endless variety of supplementary materials and tools: inks, pens, crayons, candles and wax crayons for wax-resist; scalpels, knives and a mount-cutter for splicing and trimming paper; acid-free tape and basic masking-tape; string for testing perspective and vanishing points; and a collection of watercolour papers accumulated over the years.

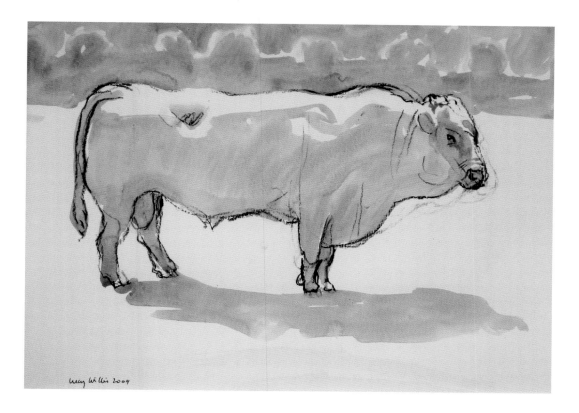

*The White Bull*

45 x 58 cm (18 x 23 in)

For a series of bull studies, I took a small sketchbook to draw the bulls from life. Back in the studio I enlarged the sketches by eye and drew them in charcoal before laying on a few simple washes in watercolour to give the sense of sunlight and shadow. Finally I sprayed fixative over the charcoal lines to stop them from smudging.

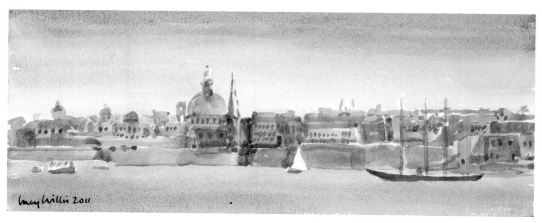

*Valletta Skyline, Malta*

14 x 33 cm (5½ x 13 in)

I took a small bag of painting equipment on a boat trip around the Grand Harbour at Valletta. Seated on the deck before the boat set off, I just had time to make a start on this little watercolour on an offcut of good-quality paper.

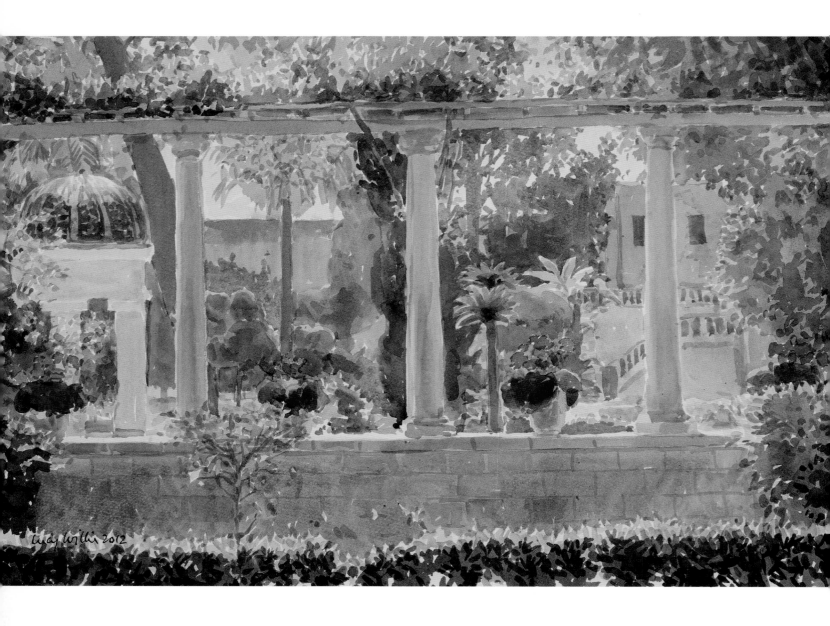

*The Palace Garden at San Anton, Malta*

38 x 56 cm (15 x 22 in)

Occasionally I want to paint a pure bright colour, so for that purpose I clean an area of my paintbox palette with water and a tissue so I can mix without the risk of any leftover pigment deadening the result. Here I have used pure Cadmium Red and a mix of Cobalt Blue and Winsor Violet for the bright flowers.

*Valletta Arcade, Malta (detail)*

To demonstrate the use of opaque white body colour, here is a detail of the painting *Valletta Arcade*. I initially included the figure in blue, just as I saw her, at the left-hand edge of my composition.

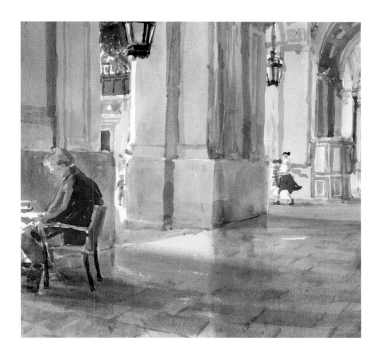

*Valletta Arcade, Malta*

44 x 60 cm (17½x 23½in)

Later I decided that the figure was just too distracting, so I removed her. With a combination of careful washing out, overpainting with white body colour and adding shadows and reflections, the composition became calmer, leading the eye down the arcade towards the far door.

Lucy Willis 2002

# Handling watercolour

The secret of effective watercolour painting is the control of water, since it is the dilution of the paint that determines the depth of tone and that in turn is crucial if you want to convey an impression of light and shade. With practice this balance comes as second nature, and the rapid series of judgements that determine the success of a painting can be unconsciously made. For the beginner, however, it can be as baffling and frustrating as learning to play the violin from scratch; it is a matter of lots of practice, with plenty of scales and arpeggios, before things start to flow and you find you are pleased with your results.

*Agia Triada, Crete, Greece*
42 x 59.5 cm (16½ x 23½ in)

# Transparent washes

In my experience, the best way to learn how to handle watercolour is to have a large supply of small pieces of good-quality paper and be prepared to waste some of it. Try applying the paint in different ways: for example running two colours together by placing them so close that they merge; placing two colours next to each other without them merging by leaving a tiny gap; painting rectangular shapes that start dark at the top and, by adding more water to your colour, fade into light at the bottom. Only by playing around in this way will you gain an understanding of the elusive qualities of the medium and be able to achieve the results you have in mind when it comes to applying them to a more considered painting.

## Basic shapes

Once your handling of water and paint is starting to develop, try simple subjects. Don't be afraid of making mistakes; be prepared to start again on a fresh piece of paper rather than labouring over an error when things have gone wrong. Recognizing when the freshness of the paint has been lost is a key moment to cut your losses and try again.

For these first paintings I recommend a basic shape such as a brick or a bowl or an egg. It is astonishing how immensely challenging this can be when you start to study the shadows and the light and to judge the amount of water you need to add to your paint

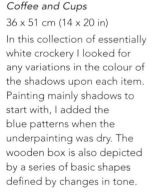

*Coffee and Cups*

36 x 51 cm (14 x 20 in)

In this collection of essentially white crockery I looked for any variations in the colour of the shadows upon each item. Painting mainly shadows to start with, I added the blue patterns when the underpainting was dry. The wooden box is also depicted by a series of basic shapes defined by changes in tone.

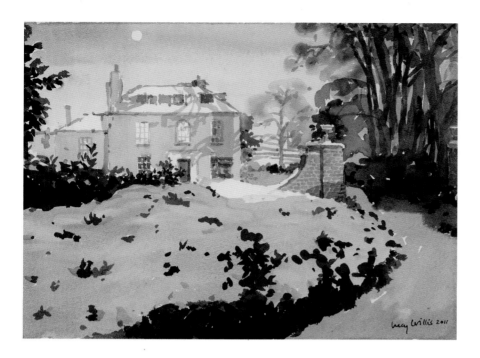

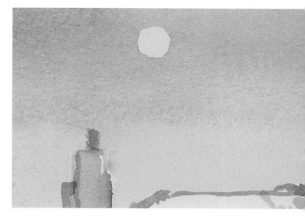

*Evening Sun and Full Moon (detail)*
In this detail you can see how crisp-edged the circle of white paper representing the moon is.

*Evening Sun and Full Moon*
28 x 38 cm (11 x 15 in)
By carefully painting my blue wash for the sky around a small, circular patch of bare paper I made a full moon of equal brightness with the sunlit snow, also left as bare white paper.

mixes to get the right tone, even before you consider the colour. Gradually work up to more complicated subjects such as a shoe or a jug. At this stage, don't multiply your problems by adding a second object; that can come later.

When I painted *The Bespoke Brogue* (p.46), I mixed a full range of tones within a limited range of colours; I could concentrate on shape, proportion and tone without too many bright colours to deal with. For the black interior of the shoe I needed the very darkest mixture I could achieve, using only sufficient water to make the paint wet enough to apply. Don't be tempted to keep your mix too dry in an attempt to make a tone dark enough as it will be hard to apply, leaving a broken surface with spots of white paper showing through. On the other hand, if you add too much water it will become a lighter grey and then you will need to reapply a second dark to deepen the tone when the first is dry. The right dilution will come with practice.

Finally I applied a very dilute beige wash around the shoe. This toned down both the background and the foreground and meant that the highlights on the shiny leather – white paper left bare – were the lightest thing in the picture.

Eventually you can add more objects and create a more complex still life set-up. All this practice on indoor studies will stand you in good stead when you go out into the world of landscape, sunlight and shadows.

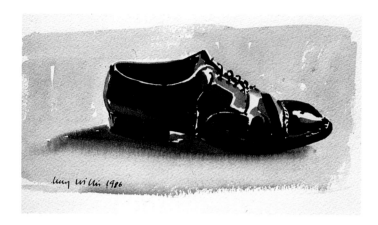

*The Bespoke Brogue* 15 x 28 cm (6 x 11 in)

Studies of single objects on small pieces of paper are a perfect way of learning to handle watercolour – both the transparency of it and the potential depth of tone.

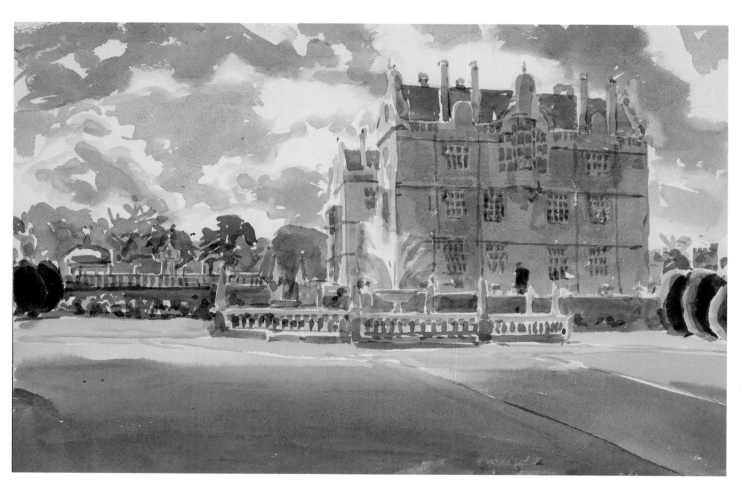

*Montacute House, Somerset, England* 28 x 37 cm (11 x 14½ in)

Painted in one sitting, this little picture required the full range of transparent washes, from the most dilute on the sunlit side of the house, through mid-tones on the shadowy side, to the dark green of the yew trees.

*Rumpled Blind in Santa Croce, Venice, Italy*

38 x 28 cm (15 x 11 in)
Although the shadow dominates almost two-thirds of this scene, it is translucent and contains a range of varied colours and reflected light. By adding enough water to my mix of colours, I have allowed the paper to shine through and the shadow does not overwhelm the subject.

# Mixing shadow tones

Shadows are elusive and it is one of the greatest challenges to analyze their colour and tone in order to paint a fair representation of what you see before you. I first look into the shadow and see what colours are there, which can sometimes be difficult as the more you look the more colours you see. I then judge the tone of the shadow and make a general mix of three primary colours – perhaps Cerulean Blue, Cadmium Red and Yellow Ochre or Cobalt Blue, Alizarin Crimson and Cadmium Yellow – and I mix to create a grey. Ready-made greys and diluted black can result in a very deadening effect, so I prefer to avoid them.

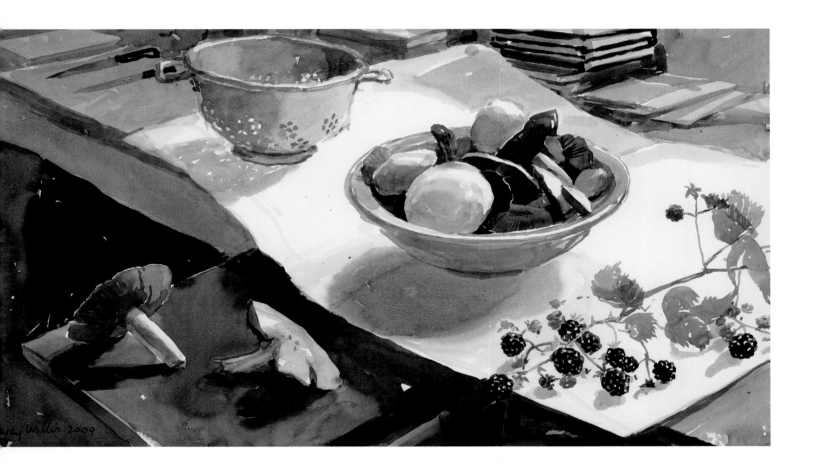

*Field Mushrooms, England* 31.5 x 56 cm (12½ x 22 in)

This painting incorporates the whole scale of tones from the blackest dark under the table (mixed with Prussian Blue and Alizarin Crimson) to the pure white of my watercolour paper. In between there is a range of browns and greys all mixed from primary colours, a few soft greens, and then a note of pure colour on the bright yellow book.

Once I have started to paint a shadow shape I can add a little more of one colour or another where I can see the colour changes hue, or a little more water where the tone becomes lighter. This is done wet-into-wet so no hard edges interfere with the integrity of the shadow.

## Working with strong contrasts

It is best to study shadows in controlled conditions indoors before venturing out into the sunshine as the effects of *chiaroscuro* are easier to analyze. This term refers to the use of strong contrasts between light and dark to achieve a sense of volume in modelling three-dimensional objects. To take advantage of this effect I often set up a still life in front of my north-facing studio window; there is no direct sunlight coming in but the shadows cast by the daylight outside are often strong and interesting and help to model the form of the objects I choose to paint.

So, for example, I set up *Field Mushrooms* (opposite) in this position and painted the arrangement with the window at an angle to my right. The mushrooms are limited in colour and I chose a few objects that would be in keeping for a palette of largely browns and greys. The shadow under the bowl is a good example of a soft-edged shadow cast by diffuse light. To render it accurately I laid on the shadow colour (mixed from Cerulean Blue, Yellow Ochre and Winsor Violet) and then quickly ran a little clean water on my washed-out brush around the edge to soften it.

You have to be careful when you do this since if you have too much water on your brush it will tend to flood back into the shadow colour, causing puddles and unwanted effects. So the control of the amount of water on your brush is essential; you can flick it hard onto the floor (as I do) or you can dab your brush on a tissue to remove excess water. Either way it is purely a matter of experience to learn how to get this right.

Watercolour has the potential to be just as strong and intense a medium as any other, with a range of tones available right through from the deepest black to the brightest white. You can see this contrast in *Scuola Grande dei Carmini, Venice* (right) where there is an

almost black doorway and also a flash of white sunlight on the building. It is a good idea to try mixing the darkest tones you can, and see if they dry as dark as you had expected. Through practice you will learn just how dense or dilute your paint needs to be.

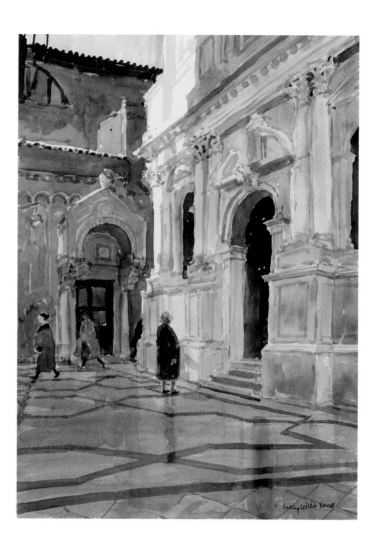

*Scuola Grande dei Carmini, Venice, Italy*
56 x 38 cm (22 x 15 in)
There are only a few patches of sunlight in this painting, so everything else was in shadow and had to be toned down to some extent. The area inside the right-hand doorway is so deeply in shadow that it appears almost black.

## Intensity of colour and tone

When a shadow falls upon an object, all its colours are usually darkened. Conversely, the colours of an object in the light will normally appear paler. In strong sunlight, colours may appear almost bleached to white, and this is where the white paper of the watercolourist is so useful. The shadows in these conditions can appear deep and dark, creating a striking contrast with the white.

Just as colour within a shadow can change, so can the tone, particularly when reflected light comes into play. Even though an area of reflected light is part of the shadow, it becomes paler due to light bounced from a brightly lit object.

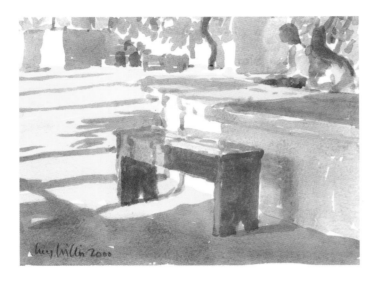

*The Blue Bench, Greece*
14 x 19 cm (5½ x 7½ in)
A simple motif – a blue bench affected by sunlight. There was plenty of interest here in the changing tones of blue (pure Cerulean for the sunlit part, Cerulean with added Cobalt for the part in shadow) and the subtly changing shadow colours around.

*Dilapidated Doorway, Tunisia* 42 x 30 cm (16 x 12 in)
Here there are three levels of tone: the bleached sunlit areas, the recesses in shadow where colour appears most rich, and deep inside the door where it is virtually black.

*The Kitchen Door, Greece*
56 x 38 cm (22 x 15 in)
The colour of the walls and door arch was all the same yellow in reality, but under the influence of sunlight a whole range of tones and subtle variations in the colour can be seen. Above the door the arch is lit up by sunlight bouncing off the ground outside, whereas the wall facing us is away from the light and therefore receiving less reflected light.

# Demonstration: Goose Eggs by a Window

Rendering hard and soft edges can be tricky to pull off at first. The best way of mastering the technique is to practice on a number of small studies like *Goose Eggs by a Window* and *In Afternoon Sunlight* (opposite) where you can try out rendering hard and soft edges on a small scale. You can choose a simple set-up, just one or two small objects on a table, and look at it in different lights. Here I have chosen soft morning light from a window and bright sunlight. You can also try illuminating your objects with artificial light and study the effect on the shadows.

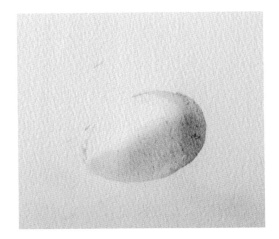

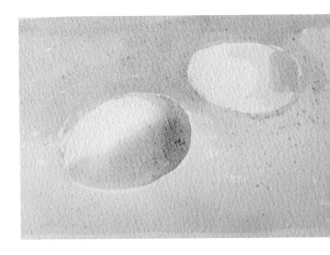

*Colour mixes for shadows*
Top: Cerulean Blue, Winsor Violet and Yellow Ochre.

Middle: Cobalt Blue, Alizarin Crimson and Cadmium Yellow.

Bottom: Cerulean Blue, Winsor Violet and Yellow Ochre with more ochre added in the lower part.

**Step 1**
I placed two white eggs on a sheet of white paper so I could study the shadows, the colours and the tonal values. I began by making a few light marks in grey and then painting the whole shadow on the nearer egg. I varied the colour within it where I saw yellow reflected light and softened the top of the shadow by running clean water along the edge of my wash so that it would blur.

**Step 2**
I established the position of the second egg and laid on the background wash so the light tops of the eggs would appear the lightest parts of the picture. I left this to dry before continuing.

## Step 3

*Goose Eggs by a Window*
15 x 23 cm (6 x 9 in)

When the paper was dry to the touch, I put the cast shadows under each egg, blurring the edges of each area of dark. Finally, I darkened some of the tones within the eggs to make the three-dimensional effect stronger.

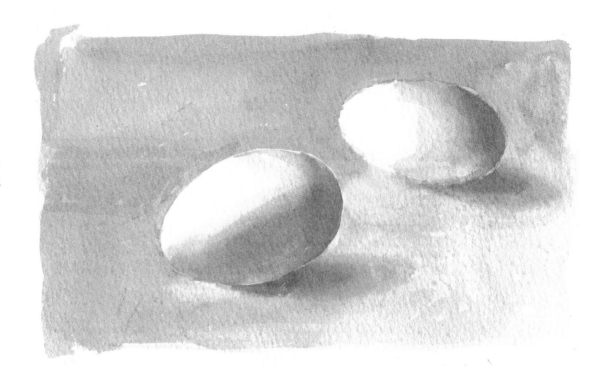

*In Afternoon Sunlight*
15 x 23 cm (6 x 9 in)

Later that day I attempted a second, similar study of the eggs when bright sunlight was pouring through the window. The edges on the shadows cast by the eggs are much sharper than those in the first study where there was softer, ambient daylight.

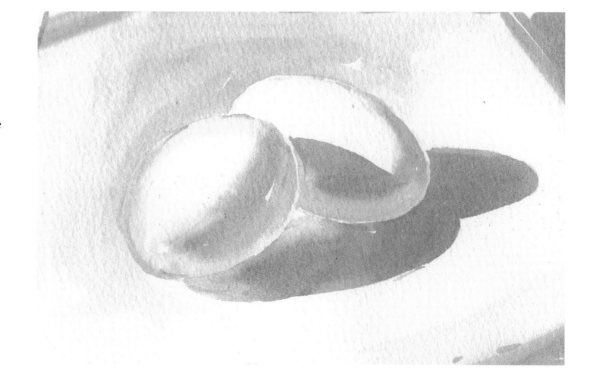

# Painting shadows

When you have a subject with areas of strong sun alternating with shadow, it helps to look at it with half-closed eyes to simplify the tones. The whole image becomes a bit of a blur but the basic shapes of light and dark are easier to see, making the shadow pattern clearer.

Once you start putting on the paint, it is important to have a clear strategy in your mind before you start to apply shadows so that you don't run into difficulties halfway through the process. For example, if you have a large area of shade, as in the foreground of *Geese in the Snow* (see p.69), try to apply it in a single wash even if it is a fairly complicated shape.

You need to avoid running out of your shadow colour halfway through, for if you have to pause to mix more colour the edge of your wash could dry, leaving an unwanted line when you restart with the new mix. So mix plenty of colour at the outset and if you do run out before your shadow shape is complete, keep pushing at the edge already laid on the paper while you mix, so that it does not dry in one place. If this is unavoidable, try to make the join of your two areas of wash in a place where it can be part of the composition. Don't worry if the colour mix changes slightly sometimes, for you can often see myriad colours within one shadow.

Of course, how easy you will find it to lay on a large shadow wash will depend on the dryness of the atmosphere in which you are working. Hot climates make this sort of extended watercolour wash much more difficult, but you can compensate by adding a little more water than you normally would and working with the paint as wet as you can, while still keeping control.

If the shadow areas you are depicting are smaller or more broken up, such as tree branch shadows, you can take your time a little more. However, you still need to make the filigree shapes in one continuous application so that the overall effect is of one shadow laid onto the surfaces on which it is cast (see *Under Tamarisks by the Sea*, p.33).

## Colour in shadows

In paintings where the sun is very strong, the shadows are where the colour tends to be more visible. The sunlit areas are relatively easy to deal with, by leaving white space in the first instance. Once you have a strong impression of sunlight working well in the painting you can then add the slightest hint of dilute colour to the patches of sunlight.

Colours in the shade tend to be cool and at the blue/mauve end of the spectrum, whereas sunshine often adds a note of warm colour to a brightly lit surface. A pale wash of yellow or orange will suffice, but make sure you do not darken the tone too much or the sense of sunlight will be diminished.

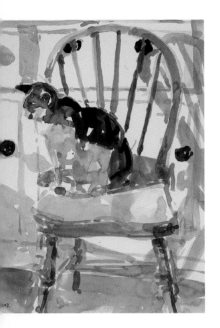

*Cat on a Kitchen Chair, England*
35.5 x 25.5 cm (12¾ x 10 in)
In this quick study it was important to untangle the shadows from the chair and the cupboard behind, so I half-closed my eyes to see patterns of tone rather than detail.

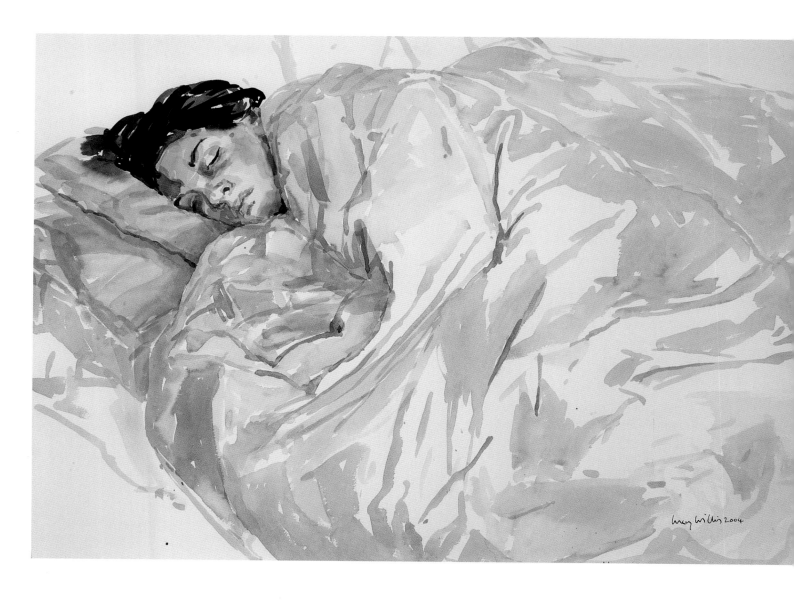

*Sarah Sleeping* 58 x 84 cm (23 x 33 in)

A range of warm and cool colours and subtle mid-tones were present in the shadows on the rumpled white bedding. Only when I painted the sleeping figure's hair did I use a really dark strong colour for maximum contrast.

# Leaving white paper

It is possible to paint watercolours on paper of any colour, provided it is fairly pale. However, after a few experiments with coloured and cream papers I returned to white or very slightly off-white as it gives the brightest tones and the greatest potential for translucency.

Just as you might leave white paper to denote the highlights on a shiny shoe (see *The Bespoke Brogue*, p.46), so you can do when denoting bright sunlight. Although I may touch in hints of colour later, I find it helpful to leave highlight areas completely bare while I work on the shadows as this way I am more likely to succeed in representing the strong sense of sunlight that I am after. In *Agia Triada, Crete, Greece* (see pp.42–3) there is only one small area of bright light but that area is crucial to the whole painting; it suggests the heat of the sun that you might feel if you walked through the gateway. I blocked in shape after shape until the whole surface of the paper was toned down so as to give maximum impact to the crucial flash of sunlight on the middle ground.

A more extreme use of the white paper can be helpful when you are painting snow scenes in sunlight. *Garden Bench in Winter* (see p.105) shows how some very minimal applications of shadow colour in carefully considered shapes can create the impression of snow. Take care to keep sunlit parts clear of any tone to give maximum brightness and only add colour to define shadows upon the snow.

# Demonstration: Summer Veranda, England

With a complex composition like this, full of little patches of light, it is important not to burn your boats by putting large areas of wash on the paper at the beginning and thus lose the chance to retain a highlight where you need it.

**Step 1**
I began by building up a series of markers all over the surface so that I had the idea of the composition in place before committing myself to larger shapes. I used the point of my large brush, dipped into a variety of greens, greys and pinks, to lightly and rapidly plot the filigree of leaf shapes that would gradually build up as the painting progressed.

**Step 2**

Next I mixed a neutral grey colour so that I could pin down the shadows on the ground, then moved across the picture building up detail in a loose but controlled way, still taking care not to paint over my brightest areas. Before applying the intensely dark trees I made marks to position the figure and then painted carefully around her head giving a crisp edge to the sunlit form.

**Step 3**

Never losing sight of the parts of the painting I wanted to keep white, I gradually filled the spaces. On the foliage I used mostly dabs and small broken brush strokes so that a sparkle of light would remain on many of the leaves.

**Step 4**

*Summer Veranda, England*
43 x 56 cm (17 x 22 in)

Finally, I toned down the white wooden structure on the far right so that it appeared to be in shadow, and also all the foreground plants beneath it to enhance the effect of the sunlight on the paving stones. A little extra detail on the dark trees also increased the contrast with the translucent green creepers in front.

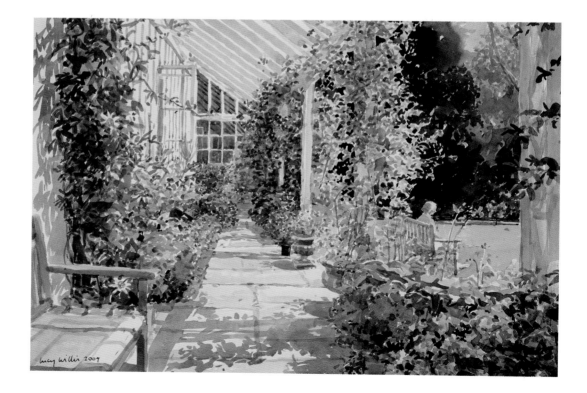

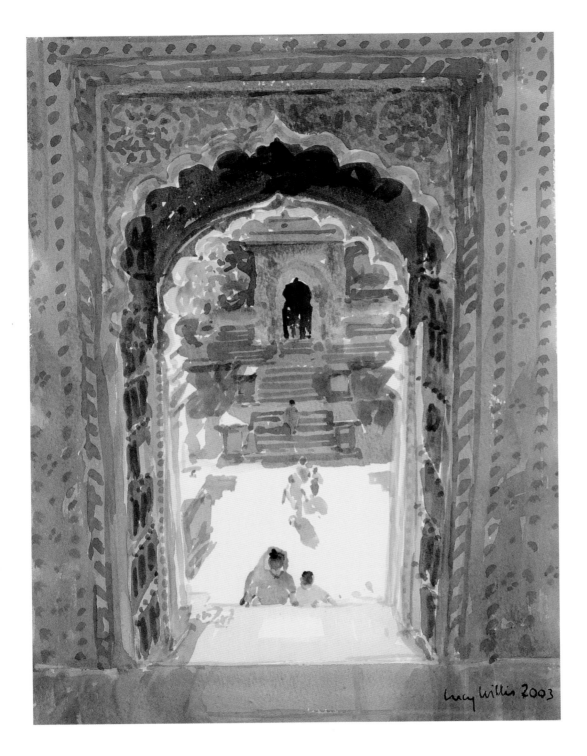

*The Maheshwar Temple, India*
38 x 28.5 cm (15 x 11¼ in)
Reflected sunlight glows under
the two arches, bounced up
from the sunlit courtyard. I took
care to keep the light areas very
pale to create the feeling of
heat and intense sun. The rim
of the doorway and threshold is
warm and bright, painted with
dilute tones of yellow ochre, for
maximum contrast to the grey
shadow of the much cooler-
coloured near wall and floor.

# Negative spaces

One of the skills required to enable you to leave white or pale areas in watercolour is an ability to see negative spaces. These are the shapes between things rather than the thing itself. For example, a pale fence against a dark background would require you to paint the dark spaces rather than the fence; a white chair against a blue wall would require you to look carefully to assess the blue shapes. When painting a watercolour it helps to think of your picture rather like a jigsaw puzzle, building up the image by incorporating both positive and negative shapes, thus minimizing over-painting and keeping the surface and the edges of the paint fresh.

In *Dora's Loggia*, the arches are defined mainly by what can be seen beyond them – the negative spaces. I also had to define the shape of the little white table and pot plant by painting the darker wall and foliage behind them.

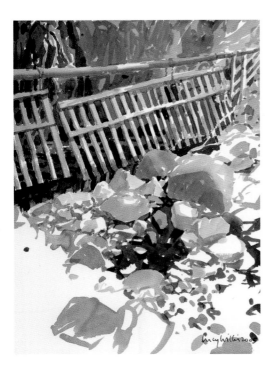

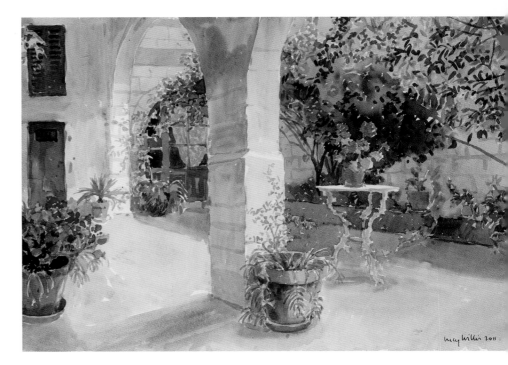

**The Drop Gate, Mull, Scotland**
38 x 28 cm (15 x 11 in)
Once I had established the main patterns by painting the negative shapes between the fence slats I added details of the stream and pebbles and a suggestion of dappled shadow.

**Dora's Loggia** 40 x 60 cm (15¾ x 23½ in)
The bright blue woodwork of the doors and windows has foliage or flowers in front of it. It was important to put these leaf and flower shapes in position before painting the blue interlaced behind. It is much better to plan ahead in this way than to try placing, say, a red flower on top of a door already painted blue.

# Rescue measures

Paintings do not always hit the mark immediately, but they can often be improved and rescued. If a painting lacks focus you can sometimes add an element to make it more interesting; other times you may need to remove parts that detract from the overall success of the composition. By washing out the paint with clean water and then using a combination of overpainting with darker transparent colours or opaque body colour you can render the altered area almost indistinguishable from the rest of the painting.

**The Forgotten Garden, Greece (stage 1)**
I painted this garden just as I saw it, relishing the patterns of light and shade on dilapidated stonework. Later, I thought perhaps it needed a little more going on to make the picture interesting. I have a stock of photos from which I can pick details if I need to add something extra to a painting, such as a figure or an animal.

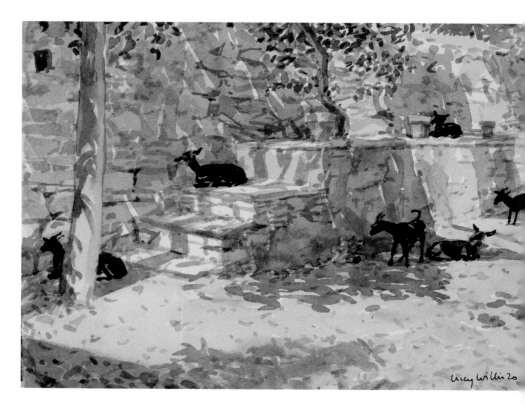

**The Forgotten Garden, Greece** 38 x 28 cm (15 x 11 in)
I had some photographs of goats and I decided to use their sitting and standing poses to enliven my picture. I painted the animals in dark tones so that they would cover any marks and textures beneath them, using pure black for the nearest standing goat.

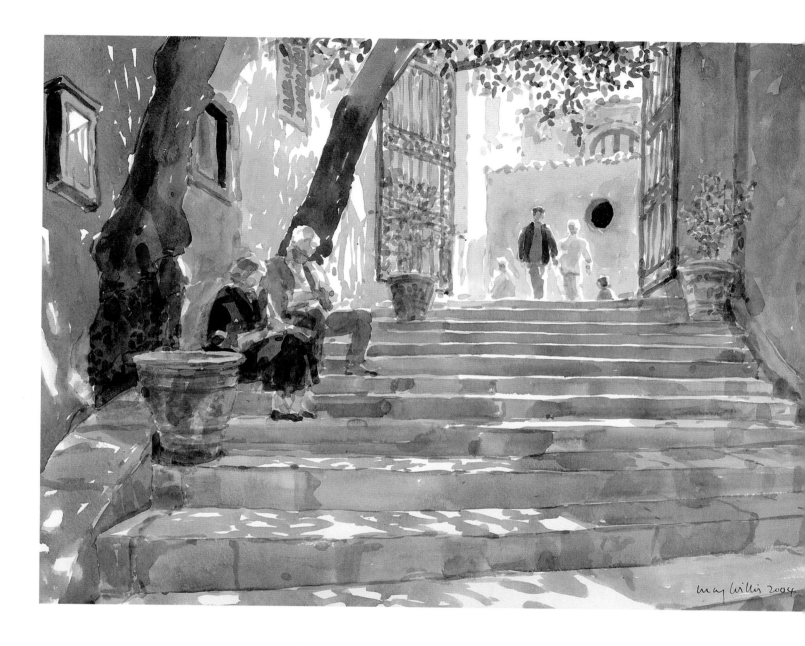

*Steps to the Roman Washing Place, Sicily, Italy* 44 x 57 cm (17½ x 22½ in)

Originally I painted three figures sitting on the steps. The foremost one was not entirely convincing, so I lifted a little colour where her legs had been and when the area was thoroughly dry I painted a large flower pot there instead. Her upper body is just visible in the texture of the tree trunk.

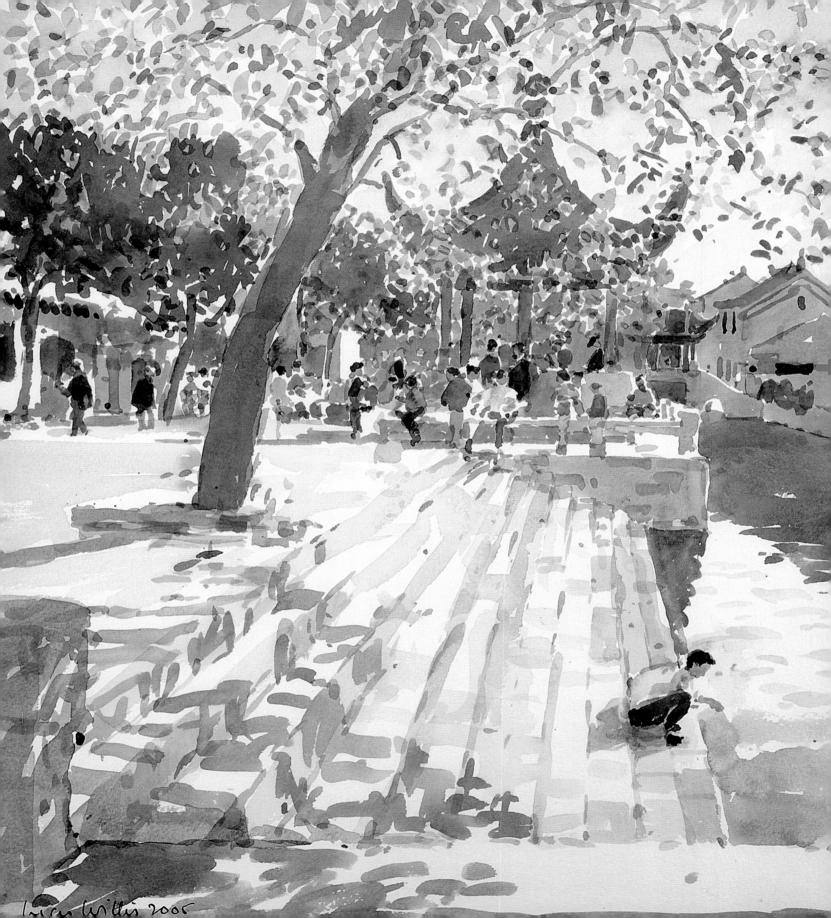

# Practicalities

The previous chapter addressed some of the technical difficulties involved in painting sunlight and shadows; now we shall look at the more practical problems and how to solve them so as to achieve the paintings you have in your mind's eye.

Working outside is a very rewarding way to paint, but you may need to deal with all sorts of weather, from hot days that dry the paint swiftly to times of rain or snow. Even if you are painting indoors during daylight hours, the light will be affected by the strength of the sun outside. At night, when there is no sunlight at all but shadows are all-pervasive, you will find that electric light gives a very different kind of glow to that of daylight and often makes for strongly atmospheric paintings. As an artist, it helps if you can adapt to circumstances when attempting to paint the light and shade that you observe.

*Autumn in Mudu, China*
43 x 56 cm (17 x 22 in)

# Working with the weather

There are many exciting things about painting, one of them being that there is no such thing as 'bad' when it comes to weather: a storm can be dark and evocative and a rainy scene can also be full of potential. Shadows are often beautifully subtle and atmospheric on a cloudy day, so although the idea of sitting outside with your easel on a bright sunny day is a tempting one, it would be a mistake to limit your location paintings to fair-weather days.

When you are going to paint outside it is important to remember that the climate plays a large role in determining how you handle watercolours. Your paint will dry almost instantly if the atmosphere is very dry and hot, so you will need to compensate by adding more water to your mix and working more quickly than usual. At the other extreme, if there is rain or high humidity, you will be frustrated by the slow drying of your washes, holding up the progress of your work. Try not to be impatient and rather than overpaint while a wash is still too wet, work on another part of the painting until the previous wash is dry to the touch.

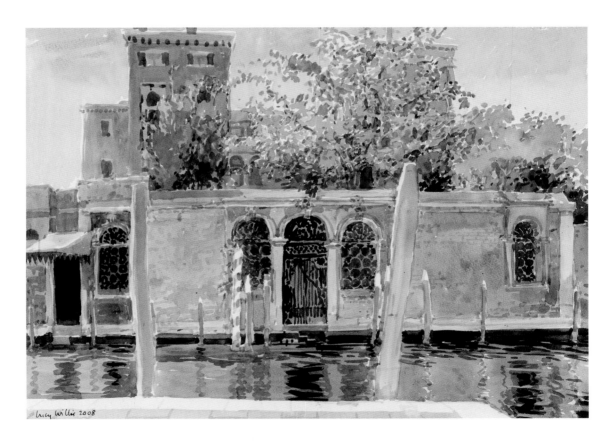

*Water Gate on the Rio Ognissanti, Venice, Italy* 43 x 60 cm (17 x 23½ in)

On this misty morning the light was flat and consistent and I was inspired by the gentle greys and the close range of colours. For two hours there was no direct sun, so I could set up on the pavement with a view across the canal to this grey and atmospheric scene.

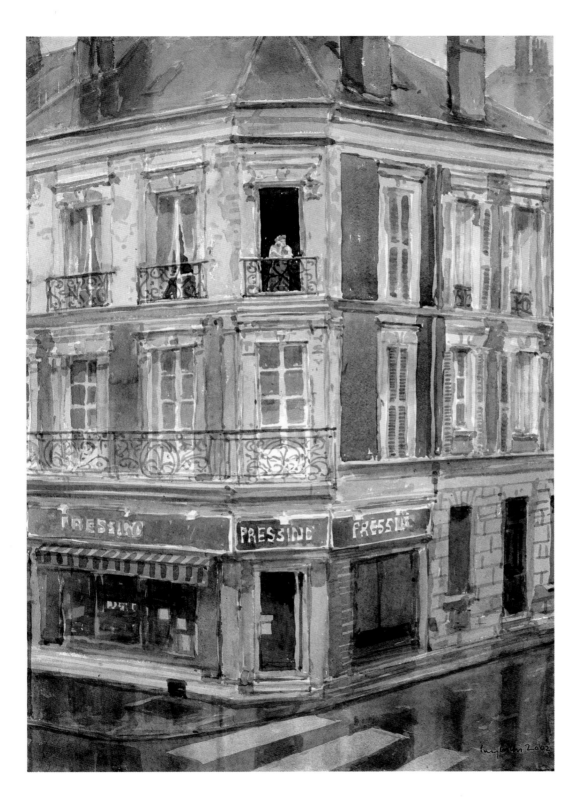

*Pressing, Nemours, France*
60 x 43 cm (23½ x 17 in)
On a rainy day the light is flat, so the only shadows here are under the recesses of the windows and a slight change on the angle of the striped awning. The reflections on the road are the telltale signs that succinctly evoke a rainy day.

# Catching the moment

In wet weather it may be necessary to look out onto the rain-soaked world from a sheltered position, to confine yourself to painting indoors or to take a photograph. I had the idea for *Pressing, Nemours* (p.65) when I was looking out from my hotel balcony at the building across the street. As I watched, a woman opened the window opposite and also looked out at the rain. I had no time to sketch, so I reached for my camera. I painted the picture from the photograph when I got back to England, finding endless fascination in the repetitions and complications of the architecture and the reflections on the roof and the rain-washed zebra crossing.

*The Undercliff, Lyme Regis, England*

26 x 38 cm (10¼ x 15 in)

By adding the shadow across the foreground of my painting I made a contrast with the pebbled beach beyond and created the sense of fleeting sunshine.

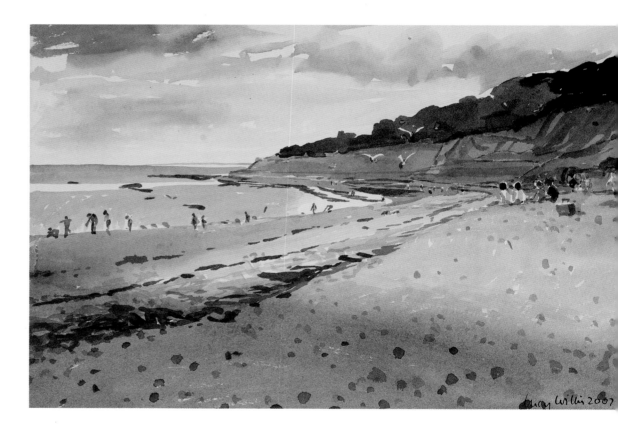

Sometimes the colours and tones of a scene can change radically within a short space of time if the weather is variable. My two paintings *The Undercliff* and *Lyme Regis* (above and opposite) are a good illustration of this. The first was painted in the morning when clouds were passing in front of the sun, which was high in the sky; I painted the latter from the same spot during the afternoon, by which time the sky had become overcast and the sun had moved nearer the horizon, lighting up the sea from behind the distant cloud formations. Most of this painting's surface needed to be toned down in order to emphasize the brightness on the sea and the bright rims of cloud.

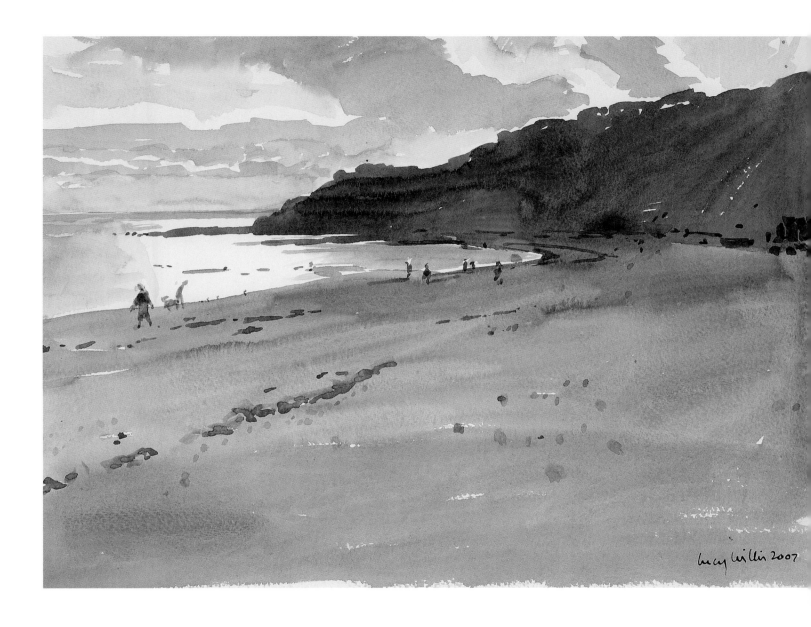

*Lyme Regis, England* 28 x 39 cm (11 x 15½ in)

By the afternoon the day had become overcast and the beach and hills beyond were enveloped in a gloomy but atmospheric shade. Only the sea was bright, reflecting a hidden sun.

# Snow, wind and sun

There can be no better opportunity for looking at shadows than when the sun comes out after snow has fallen. On a bright day the shadows on snow usually take on the colour of the sky, reflecting blue on the areas where sun does not shine directly. *Geese in the Snow* (below) is an example of this: the snow and the geese which are in shadow have acquired a bluish hue. A single goose in sunlight is left as stark white against the shadow on the ground. Because watercolour is so slow to dry in the cold air I waited until I was indoors again, and the shadow wash was completely dry, before adding the footprints in the snow on top.

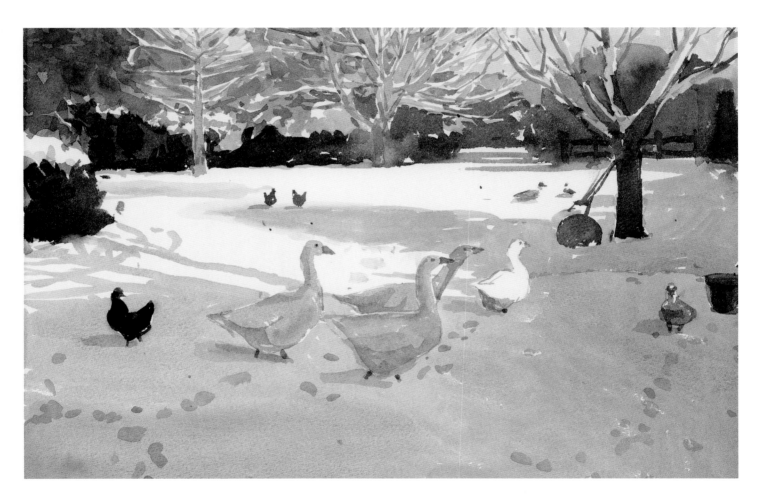

*Geese in the Snow*
28 x 38 cm (11 x 15 cm)
Freshly fallen snow provides a surface for shadow patterns which absorb the colour of the sky. Here I mixed Cerulean Blue, a touch of Winsor Violet and in places a hint of Yellow Ochre.

*Aleppo Citadel, Syria*
42 x 60 (16½ x 23½ in)

In spite of the heat and the glare I needed to sit in the sun to paint this particular view. I placed a few figures against the low wall, and left spaces for more on the right. I intended to finish them by adding some shapes of coloured clothing in the spaces and perhaps also put something in the foreground. But I realized it gave a better impression of the heat and sunlight if I left the whole foreground just as it was, and the painting, in a sense, unfinished.

*On the Citadel, Aleppo, Syria*
28 x 38 cm (11 x 15 cm)

Having coped with fierce sun combined with wind and sand I finished the painting with two figures which fortuitously came into view, adding a welcome punch to the overall paleness of the stone structures surrounding them.

One of the worst enemies of a painter on paper is a high wind. I usually work with my paper resting on a board or portfolio on my knee and try to hold the paper down with my free hand, but it is a good idea to carry clips or tape to secure it. When I chose my position for *On the Citadel, Aleppo* (below) I was mainly looking for shelter from the sun and had not anticipated a wind tunnel effect, but after a short time I was assailed by a ferocious gale that howled in from the desert and scattered sand all over my painting. I carried on as best I could but when the paper was blown out from under my hand I almost gave up. Eventually the wind dropped and all was calm again. Just as I was wondering if I should continue after this difficult start, two women in striking black climbed the path in front of me. I quickly added their shapes as they ascended and suddenly the painting had a focus, so I was glad I had weathered the storm.

Almost as difficult as the wind and the rain is relentless sunshine with no shade. Sometimes you cannot get away from it if you are determined to paint a particular subject, and all you can do is take whatever measures you can and then set to work as fast as possible. When I painted *Aleppo Citadel* (above, left), I was keen to show the imposing structure from a low viewpoint, from the ground looking up. I used my open paintbox, held up over the paper in my left hand, to give just enough shade for me to apply the paint in each area before it was sucked into the dry paper.

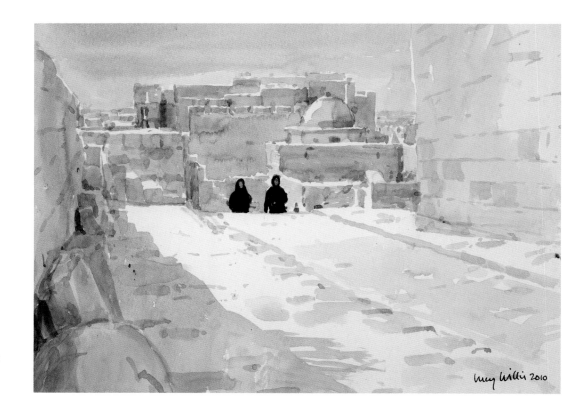

# Different times of day

Whether you are painting indoors or out, a major factor in determining the appearance of your subject is the time of day. Many artists avoid painting outdoors in the middle of the day because the sun is at its highest and shadows can be short and the light glaring and stark. This is especially the case when you are nearer the Equator in hotter climates. Also, from a practical point of view it is almost foolhardy to go out and paint at noon in India, for example, unless you have an area of shade to paint in that will not diminish as the sun moves round.

Paintings of morning and evening light are more manageable for this reason and offer marvellous subject matter. Since landscape painting began, watercolourists have headed outside at the crack of dawn to catch the evocative early light, as I did when I painted *Early Morning, Lijiang* (below). Similarly, the period when the light starts to fade at the end of the day offers great atmospheric potential, but you have to be quick in order to finish a painting before dusk falls.

The two paintings *Croyde Beach, Afternoon* and *The Blue Tent, Evening* (opposite), painted three years apart, illustrate the difference that the time of day makes to the same scene. The bright, flat light of the first could not be more different from the second, where the low sun is just shedding its last rays on the sea. The sand, yellow before, has become dark and rich in tone compared to the flare of light on water.

*Early Morning, Lijiang, China*
24 x 36 (9½ in x 14¼ in)
Going out before breakfast, I started my watercolour in a deserted street, attracted by the patterns of shadows and sunlight filtering through the trees. As the painting progressed people started walking to work and I managed to get some of them into the middle distance before I filled in all the spaces.

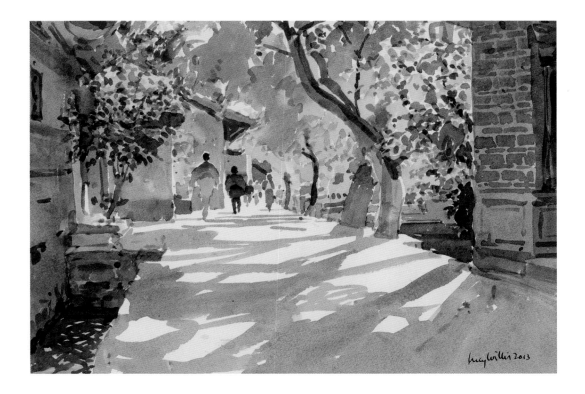

*Croyde Beach, Afternoon*
28 x 33 cm (11 x 13 in)
This was one of those afternoons when the sun was lurking but never quite coming out fully, so there were no shadows cast by the tiny figures which dotted the beach.

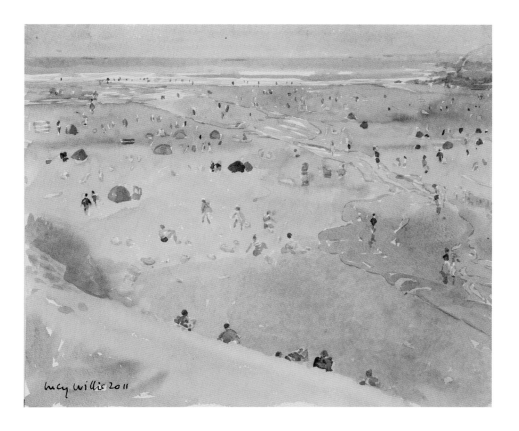

*The Blue Tent, Evening*
28 x 33 cm (11 x 13 in)
The difference in tone between bright sea and dark sand is in complete contrast to the afternoon version of this view in *Croyde Beach, Afternoon*.

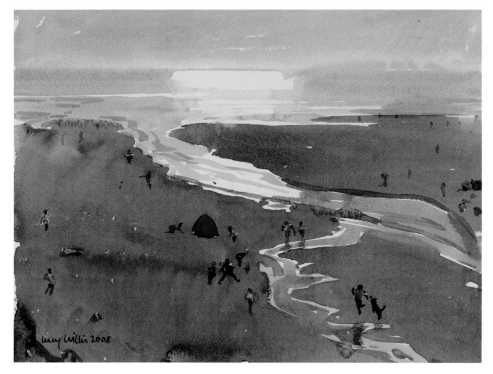

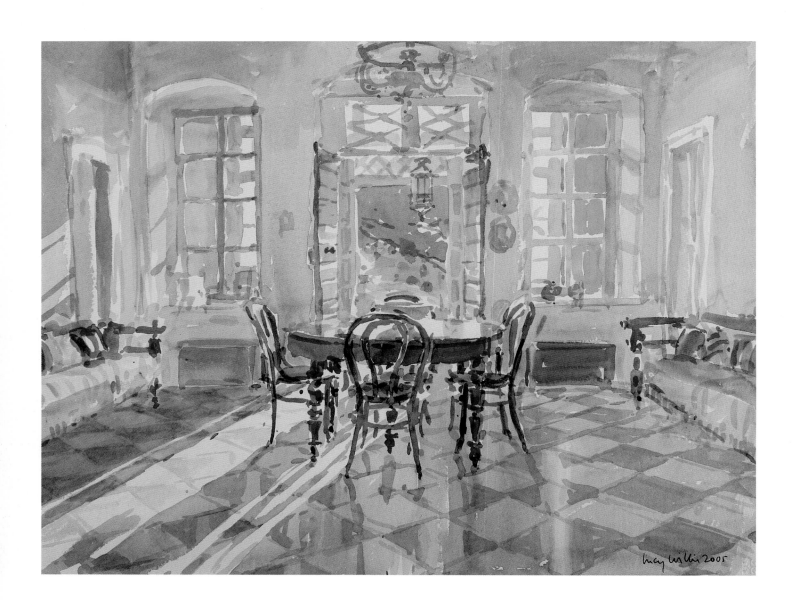

*Morning, Greece* 43 x 56 cm (17 x 22 in)

This is the first of a series of three paintings of the same subject at different times of day. The low early-morning sun streams in through the open door, lighting up the whole interior and heightening the colours.

Indoors, too, the time of day can make a huge difference. Try painting a series of pictures of the same interior from the same position but at different times of day and study the changes in the light. The three paintings *Morning*, *Noon* and *Night* (below, left and right and opposite) are an example of this exercise and each picture has its own mood. I completed the series over several days and did not compare one painting with another until they were finished. Although I used my usual palette of colours for all three, the mixtures were very different for each painting: many more bright yellows and blues in the first two and more greys mixed from blues, violet and black in the night scene. Notice how the atmosphere in each picture changes according to the light.

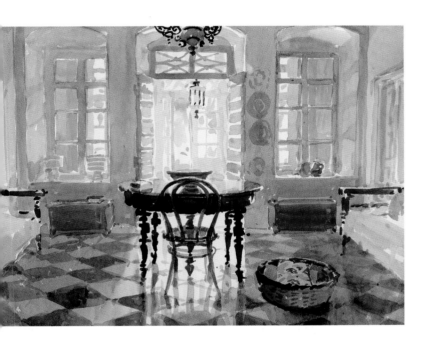

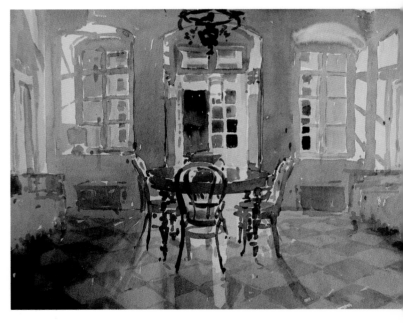

*Noon, Greece* 43 x 56 cm (17 x 22 in)
Here the outside, just seen through doors and windows, is burning with the midday sun which has moved round to the right. It no longer throws direct sunshine into the room and the table is in much starker contrast against the light beyond.

*Night, Greece* 43 x 56 cm (17 x 22 in)
A complete reversal of tones occurs at night. The outside is now dark blue-black and the electric lamp in the middle room throws a quite different pattern of shadows to that which we saw in the morning.

Night scenes are among my favourite subjects for studying light and shade, albeit artificial light rather than sunlight. Before dark the brief period of dusk is a bewitching time; the warm, yellowy light of lit windows and doors intensifies and complements the blue of the darkening world outside. *Before the Shops Shut, Venice* (below left) is an example of this. I was walking past and was intrigued by the scene, so I took a photograph in the dying light as an *aide-mémoire* for a possible painting.

*Before the Shops Shut, Venice, Italy*
25.5 x 19.5 cm (10 x 7¾ in)
I painted this atmospheric little scene as I recalled it later with the help of a photograph I took at the time. I painted everything outside the building using a range of cool colours – blues, mauves and intense darks – while restricting my palette to predominantly light, warm yellows inside the lit building. Where the light spilled out into the night I painted pale areas wet in wet, blending it with the darker pavement.

*Evening Sun Reflected, Venice, Italy* 38 x 31 cm (15 x 12¼ in)
Having started this watercolour rather late in the day, I was delighted when the evening sun was reflected in the pointed window just above the front wall. I darkened the rest of the walls to make the space recede and to make this reflected sun appear brighter.

Alternatively, I might make a drawing to work from – drawing in semi-darkness is not really that difficult. Making some notes and getting down the basic scheme of the composition in pencil is sufficient reference for a painting. In the case of *Hot Night in the Square* (below), I made a sketch of the buildings and memorized the reflections of the trees and architecture, with light from the arches repeated in the shiny marble foreground.

*Hot Night in the Square, Greece (sketch)*

15 x 21 cm (6 x 8¼ in)
A small sketch such as this can contain enough information to reconstruct a scene in a painting on a larger scale.

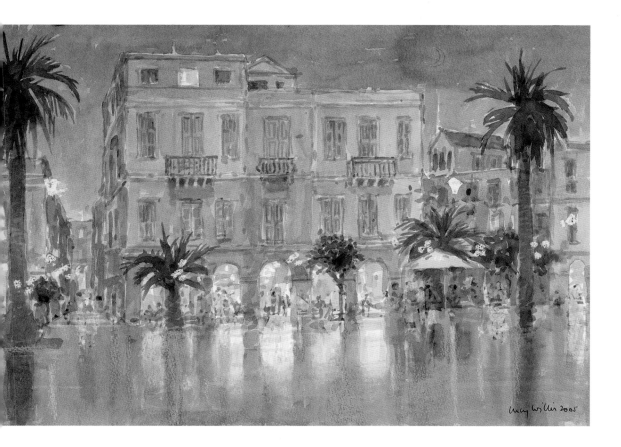

*Hot Night in the Square, Greece*

42 x 60 (16½ x 23½ in)
Remembering that there were white street lights all along the square, I made a row of dots with candle wax before I started. I could then paint the trees and buildings over the top and the lights shone through the wax resisting the watercolour.

In paintings of night-time scenes you still have to assess the lightest and darkest tones in your picture and the subtle variations in between. If you see points of light such as street lamps you can leave the paper quite clean and then work around them, gradually toning down the rest of the image to make those points appear really brightly lit. In the case of *Syros Night* (see p.76), which I also painted from a sketch, the shadows are cast by lights on the wall and the light from the open doorway.

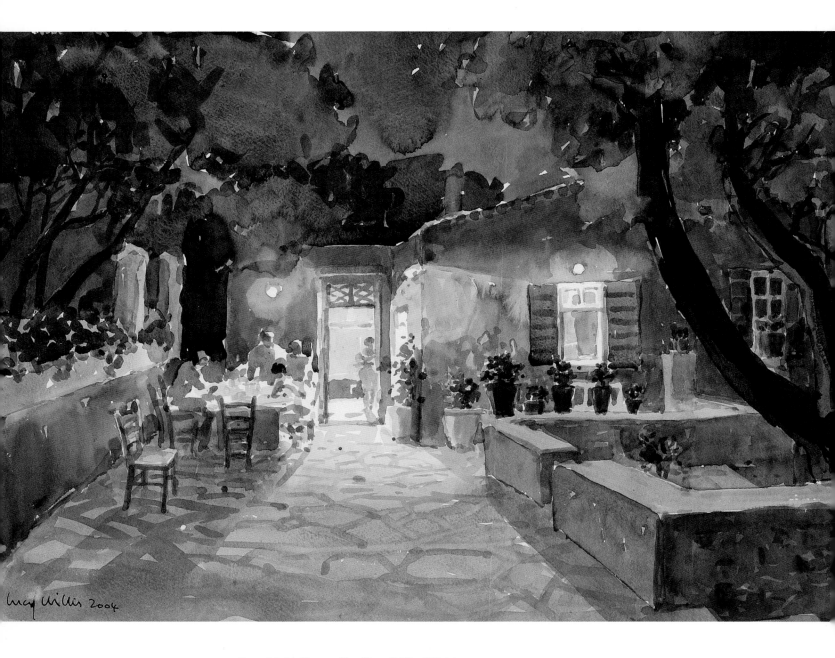

**Syros Night, Greece** 42 x 60 cm (16½ x 23½ in)

Painting from a sketch made at night, I played with the contrast of the hot yellows and reds of the house set against deep blues and greens of the sky and foliage. I applied second or even third layers of colour to the tree trunks and some of the shadow area to really intensify the sense of light by means of contrast.

# The influence of the seasons

The time of year is another factor that determines the appearance of shadows in outdoor scenes, especially in the northern hemisphere where the season can make an enormous difference to their length. In *Autumn Frost* (below) and *Garden Bench in Winter* (see p.105) you can see how elongated the shadows are when they are cast by a low winter sun. In my garden I have noticed that the sun never rises very high throughout the coldest months, slanting through the trees from a low point in the sky.

Compare this to *Door to the Garden, Summer* (see p.79), a favourite view of my garden which I have painted several times in different seasons. Here, towards the end of the morning, the sun is high and the shadows are relatively short. So at exactly the same location the shadows behave very differently according to the season: long in winter and shorter in summer. Once you start paying attention to shadows in your paintings you will find you become more and more aware of this.

*Autumn Frost*

28 x 38 cm (11 x 15 in)

When the grass is frosty the colour of the shadows changes from green where the sun shines to blue-grey where it remains cold. In autumn there is often a lovely orange glow when sun shines through the leaves, enchanced when seen against a dark background as shown here.

I painted this scene over the course of several hot summer days, seated on a low stool under a tree so that the paper was in shade and not too dazzling. I wanted to include not only the sunlit door to the kitchen garden and the white roses but also the sheds and the chicken run, so I chose a full-sized piece of paper.

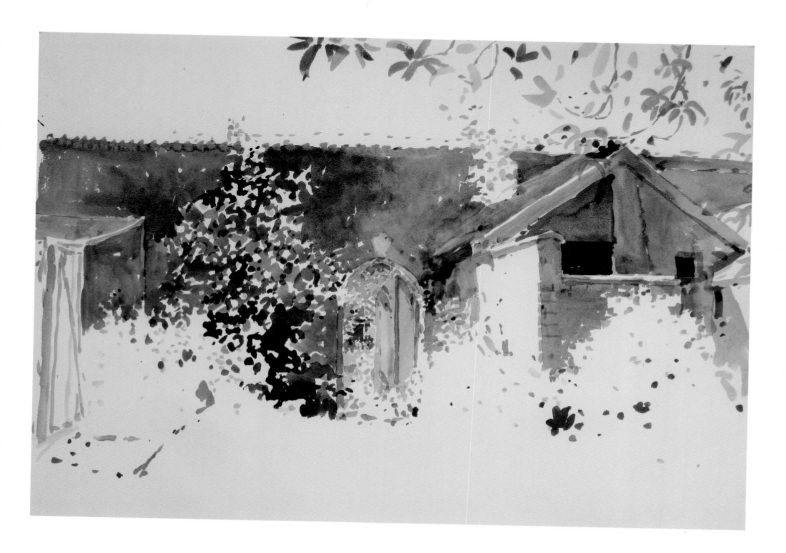

*Door to the Garden, Summer, England (initial stage)*
It is often difficult to know how to start a large watercolour like this. With high summer sun moving rapidly across the sky I concentrated on positioning the shady area of wall with a basic wash, noting key sunlit points like the wall protuding towards me. When this went into shadow I decided to stop until the sun was in the same position the next day.

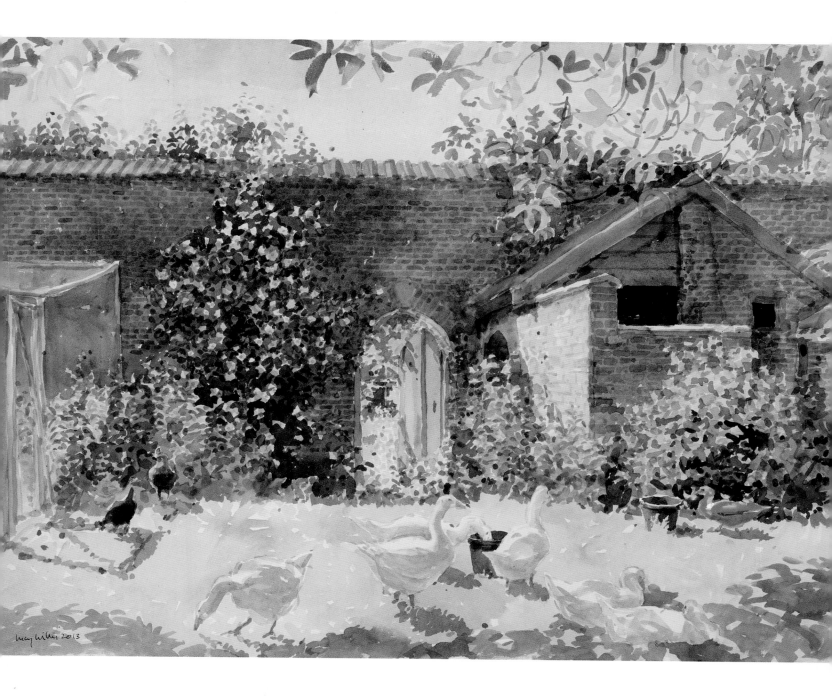

*Door to the Garden, Summer, England* 57 x 76 cm (22½ x 30 in)

The following day I worked into the broad grey-brown washes of wall, laid in the earlier stage, with warmer colours of brick patterns, superimposed carefully with a smaller brush. The colours and shapes of my geese were a good way of breaking up the expanse of green grass. I placed them by first painting the bluish shadows on their white bodies and then working the green around them. Later I applied the shadows on the grass with a darker green, making sure they were consistent with the direction of the sun.

# Painting indoors

Although working outdoors is an enjoyable and fulfilling way to paint, there are many practical advantages to staying indoors. If you have sufficient space and all the right equipment around you it is very easy and convenient to just start painting without packing everything up and setting off. The issue is the subject matter and, of course, the light.

*Chinese China* 40 x 60 cm (15¾ x 23½ in)

This still life was set up on the table in my kitchen. The light coming in from the window cast horizontal shadows across the cloth under and to the right of each object.

You can work from immediate observation of subjects that are actually before you. A still life set-up on the kitchen table or under a window can pose any number of challenges and rewards. *Chinese China* (opposite) was painted by the light of a window on the left. There is no direct sunlight casting sharp-edged shadows but there are significant shadows cast by a more ambient daylight. It is important not to carry on when the light starts to fade, since turning on an electric light to enable you to see properly would produce a quite different set of shadows.

Alternatively, if you are working from sketches, photographs or memory you may be painting pictures that bear no resemblance to your surroundings. I try to re-create the feeling of painting on the spot so that I keep the sense of speed, urgency and fluidity that makes watercolours fresh rather than laboured.

Another option for indoor watercolours is painting the figure. Portraits, life classes, or painting friends and family give endless opportunities for studying the way light and shade falls on the figure. I painted *One Man and a Dog* on a sunny day at a life drawing session at a friend's house. Her dog came to lie beside the model, the sun streamed in through the window and, although the pose only lasted a few minutes, we had a charming scene before us. Speed was of the essence in catching the shadows and the pose and the time constraint denied any temptation to get bogged down in detail.

*One Man and a Dog*
25 x 38 cm (10 x 15 in)
After starting with a few basic body shapes, I next used a few simple background washes to define the top edge of the figure, leaving a bright rim along his legs, arm and head where they caught the sun. The shadows reaching forward are as dominant in the painting as the man and dog.

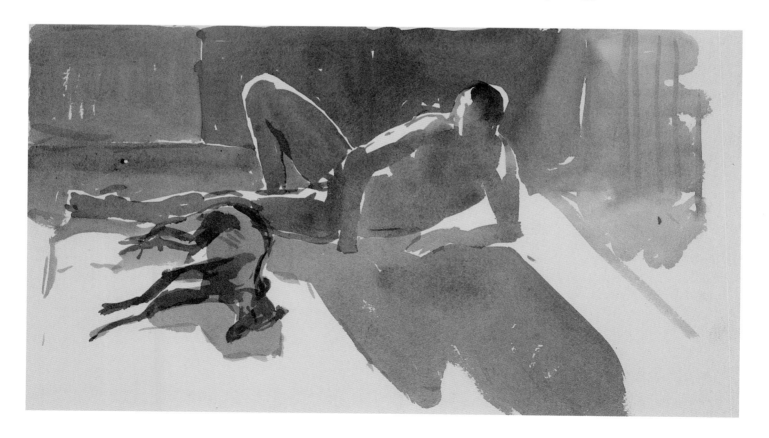

# Demonstration: The Dresser

Rather than consciously setting up a still life to create a particular composition you may simply choose to paint the room in which you find yourself. Painting your familiar surroundings can make you notice things afresh: the clutter and accumulation of favourite pots was the inspiration for *The Dresser* in my own kitchen. I could not get very far back from it, due to the width of the room, but I wanted to paint the framework of shelves head on, with minimal receding lines of perspective. Although my verticals and horizontals wavered occasionally I took care to correct them as I went along to compensate for the distortion which tends to happen when working close to your subject and close to your paper.

**Step 1**
I blocked in the structure of the dresser as a framework and started to place the individual objects using quick strokes of the brush. The sun had crept round and cast a bright patch on the left-hand cupboard. Although it only featured for a short time I could not resist faintly marking out where it fell so I could leave the white shapes and incorporate a little sunshine into the composition.

**Step 2**
Gradually I added more solidity to the objects and blocked in shape after shape until the space was starting to fill up. The reflections of a far window in the glass door panes added another note of light and a bit of extra depth to the scene.

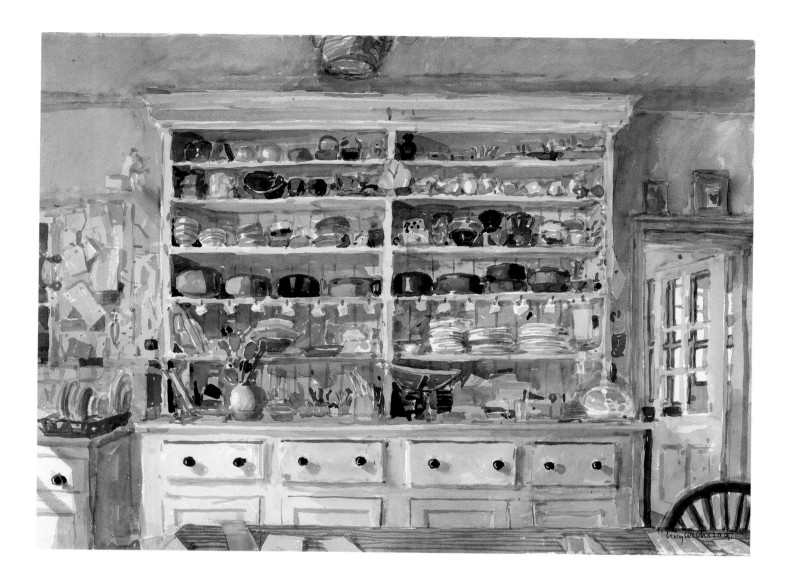

## Step 3

*The Dresser* 57 x 76 cm (22½ x 30 in)

The light from the unseen window to the left cast a shadow to the right of every object so I tried to use this to give consistency to what otherwise could be a chaotic collection of fragments. Although the sunlight had long since moved out of the picture, I strengthened the shadow shapes on the sunlit cupboard which I had marked out at the beginning of the painting (see Step 1).

# Selecting the scale

Along with the other practical decisions discussed in this chapter there is also the question of how large to make any given painting. I often buy my paper in mill packs of imperial sheets measuring 56 x 76 cm (22 x 30 in), but the majority of my pictures are executed on paper that is half or a quarter this size. However, I love to work smaller or larger than usual and you will probably want to explore different sizes too, so here we shall look at the pros and cons of working at both ends of the scale and the effect it can have on a picture.

## Working small in watercolour

Painting a small watercolour is very often a decision that is made in a split second as the subject and situation impose their own demands. Sometimes, if you are out and about, it depends on what paper size you happen to have with you. At home you may see something attractive – perhaps a flower or a cat on a rug – and want to capture it quickly, with minimum fuss, as I did with *Irises in a Mug* (see p.86).

*Gateway to India, Mumbai, India*

12 x 19 cm (4¾ x 7½ in)

From an upstairs window at the Taj Hotel in Mumbai, I had an excellent view of the famous Gateway to India. Even though the painting was small I tried to suggest a sense of monumentality. With a grey mix made up of Cerulean Blue, Winsor Violet and a touch of Yellow Ochre, I painted the main shape and waited no time at all for it to dry in the Indian heat.

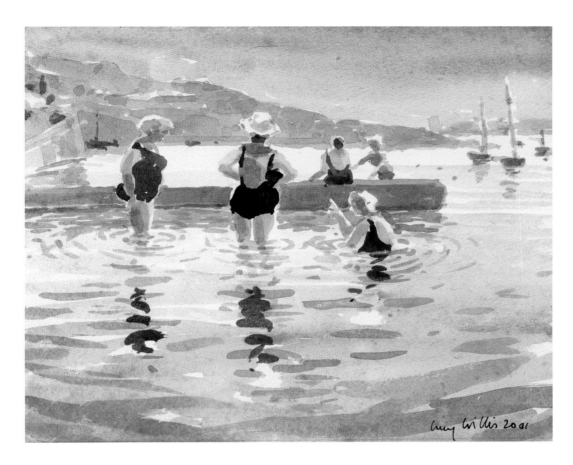

*Bathing Beauties, Greece*
16 x 19 cm (6¼ x 7½ in)
Working on a small scale has advantages when you are painting people from life. You can suggest a figure from a few basic shapes and you do not need to go into detail to achieve a stance, a gesture or a pose.

The most obvious advantage of working small is portability – a few sheets of paper can be slipped into your rucksack with your paints. Also, in terms of light and shade a small painting can be easier to execute, since if the light is changing rapidly you can place shadows on a small painting more quickly and easily than if you have to cover a larger area. If drying speed is an issue, as in hot, dry climates, it is easier to avoid unwanted dried edges if you are covering only a small area as in *Gateway to India* (opposite).

I always have offcuts from large sheets of watercolour paper in my studio and in my portfolio when I travel. Sometimes there are long, thin pieces which are perfect for little paintings such as *Hillside Café Lanterns, Lijiang* (see p.86).

*Irises in a Mug*

16 x 17.5 cm (6¼ x 6¾ in)

Placing these iris heads in front of a window with a soft shadow coming forward and a darker shadow behind made the perfect subject for a small watercolour study. When the mid-tone shadow shape I applied for the front of the mug was thoroughly dry, I could freely draw the blue pattern on the mug using the point of the same large brush.

*Hillside Café Lanterns, Lijiang, China*

12 x 36 cm (4¾ x 14¼ in)

On painting trips I usually carry a few long, thin offcuts of watercolour paper along with the more conventional larger sizes. Here I was attracted by the long row of tables with the figure sitting in the shade, silhouetted against the view beyond.

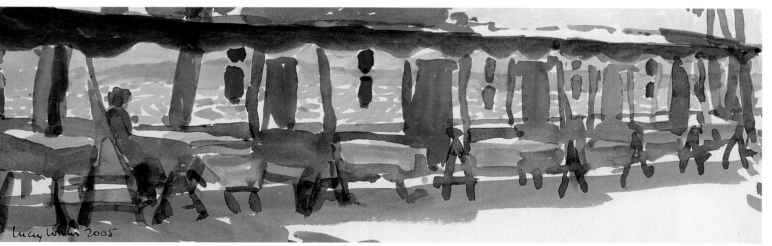

*Somerset Viaduct, England*
56 x 76 cm (22 x 30 cm)
Little horizontal shadows of trees and cattle suggest a raking afternoon sunlight in this painting. The last-minute addition of the shadow in the foreground brought the hill forward and suddenly increased the feeling of warm sunshine on the landscape stretching away beyond.

## Working large in watercolour

For me, working on a large scale is invariably a carefully considered decision. Unlike small paintings which can be quick and opportunistic, a big one needs more preparation. I usually choose a large sheet of paper when the subject I want to tackle simply has a lot to put into it. I like to expand the image across the surface and allow the viewer to be able to move closer to inspect the content, or to stand back and take in the general impression. Alternatively, I may want to use the space to emphasize an aspect of the painting, as in *Sarah Sleeping* (see p.55). By placing the head in the top left-hand corner I emphasized the smallness of the figure, leaving plenty of space to explore the subtle colours and shadows of the white bedding.

*Dawn, Gambier Terrace*
*(pencil sketch)*

Sometimes the size of a painting is predetermined. I was asked to paint a large watercolour, *Somerset Viaduct* (see p.87), for a space above a particular fireplace. For some months I visited the hill with my sketchbook and made studies of the view. When spring came I took my portfolio with a large piece of watercolour paper and painted on the spot, sitting on the ground with a board and paper on my knee. The main interest was in a narrow horizontal strip just above the centre of the painting and the farmstead below me made a stepping-stone of interest towards the viaduct. Back in the studio I painted the sky from memory, filling the top of the painting with loosely painted clouds. At the bottom I had the hill, the field sloping away – and it was only when I invented a dark shadow of a passing cloud in the foreground that it started to suggest a steep incline.

When working on a large scale I make sure I keep the painting loose and quick and allow shapes to suggest things rather than define them in minute detail. I make changes without worrying too much about tidiness or exact accuracy. Paradoxically, it is the larger paintings which appear to be more closely worked and with greater detail but this can be an illusion, particularly when paintings are reproduced much smaller, as here.

Sometimes, if it is not possible to take a large piece of paper outside to the subject, it may be necessary to work in the studio from sketches and from memory, or from photographs or a combination of any of these. *Dawn, Gambier Terrace*, for example, was painted from memory with the help of just a small pencil sketch. The idea for the painting came when I was looking from a high window in the very early morning. I could see the backs of houses opposite, and as I sat and watched the lights went on and

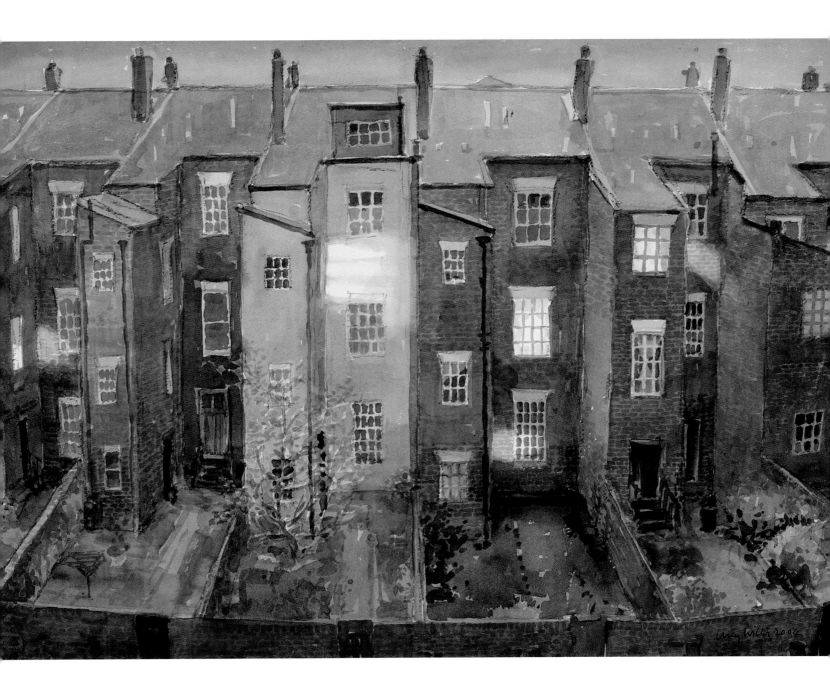

*Dawn, Gambier Terrace, Liverpool, England* 56 x 76 cm (22 x 30 cm)
Painted in the studio over many weeks, from memory and the sketch opposite, this scene
haunted me until I finally achieved the levels of dark atmosphere and glowing light that I
remembered from seeing the view months before.

the windows lit up one by one. In order to memorize the scene I closed my eyes and tested myself on the detail, but I knew that for a painting I would need a little more reliable information. I had only an A5 sketch book and pencil with me so I drew a quick sketch and scribbled some written notes on the opposite page, which read: Black drainpipes. Beige cream central section. Pinky mauve brickwork/browns. Grey slate roofs. Light blue lead flashing. Yellow windows lit, light spilling sideways. On the sketch itself I wrote 'yellow light', 'dark brick' and 'dark grass earth'.

*The City of Stone, Valletta* (see pp.10–11), on the other hand, is an example of working on a large scale exclusively from a photograph – I had neither the opportunity to paint nor even the chance to sketch the scene as I was on a moving boat passing at some speed.

Yet another approach to large-scale paintings is to work from observation indoors if it is feasible. *Cornucopia* (right), for example, was painted directly from a still life I assembled in the studio. The north-facing window is above the table, directly in front of me, so I knew I would have steady, ambient light for this prolonged effort with no sporadic bright sunshine coming in.

*Cornucopia* 56 x 76 cm (22 x 30 in)

I gathered as many different types of produce from the kitchen garden as I could find and carefully arranged them in my studio for a large watercolour. As the painting progressed I wanted to add a little more interest to the bottom of my picture, so I found some boots and flower pots to place under the table. They are all in dark shadow, making a nice contrast with the table top.

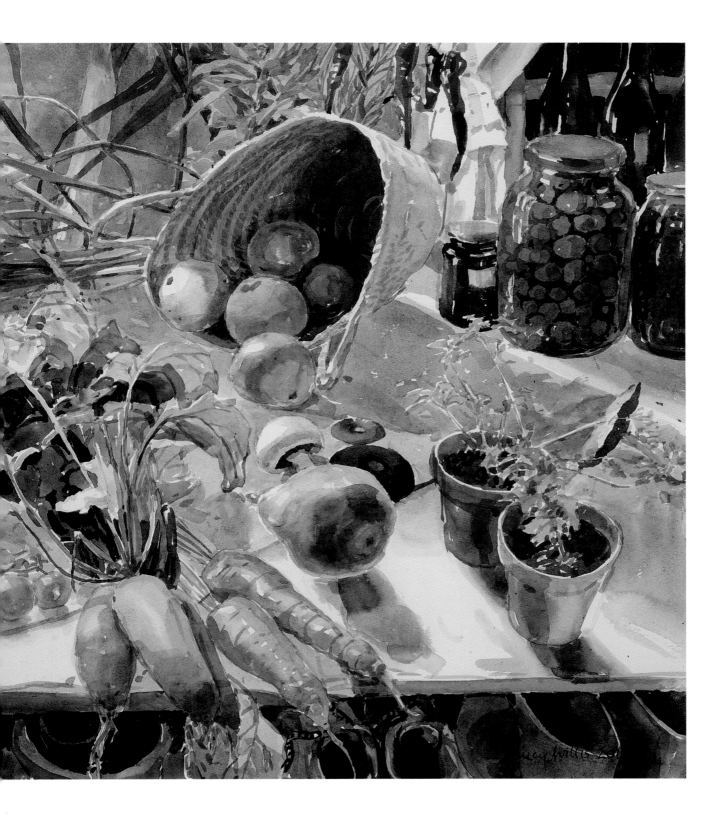

My larger watercolours are usually executed on thick, 300 gsm (140 lb) watercolour paper. This heavy weight means I can paint large washes without the risk of buckling and with no need to stretch the paper onto a board first. My choice is often an imperial sheet (56 x 76 cm/22 x 30 in) of Bockingford or Saunders Waterford. Occasionally I am asked to do something larger still – for example, when I was commissioned to paint *Autumn Afternoon, England* for a public foyer, I cut a piece of Bockingford measuring 81 x 112 cm (32 x 44 in) from an enormous roll I have had for many years.

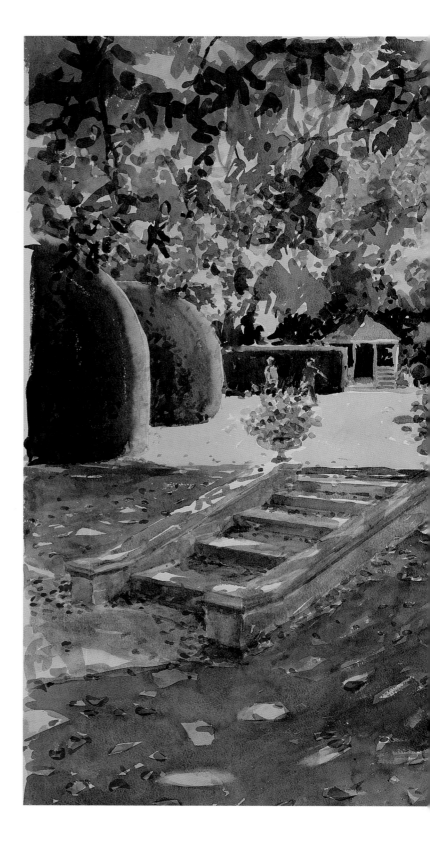

*Autumn Afternoon, England*  81 x 112 cm (32 x 44 in)

For this commission, one of the largest watercolours I have attempted, I visited the garden and took photographs. Back in the studio I made small watercolour sketches to work out a composition that used real elements (steps, lawn, bushes, tree) but in a new, imaginary arrangement. Deep, dappled shade under the tree leads the eye to the brightly lit lawn beyond. The two figures walking under the tree were added to the painting at a late stage from my imagination, as I felt more interest was needed in that part of the painting. They are mostly in shadow so I was able to paint them quite dark, thus avoiding too much of the green behind them showing through.

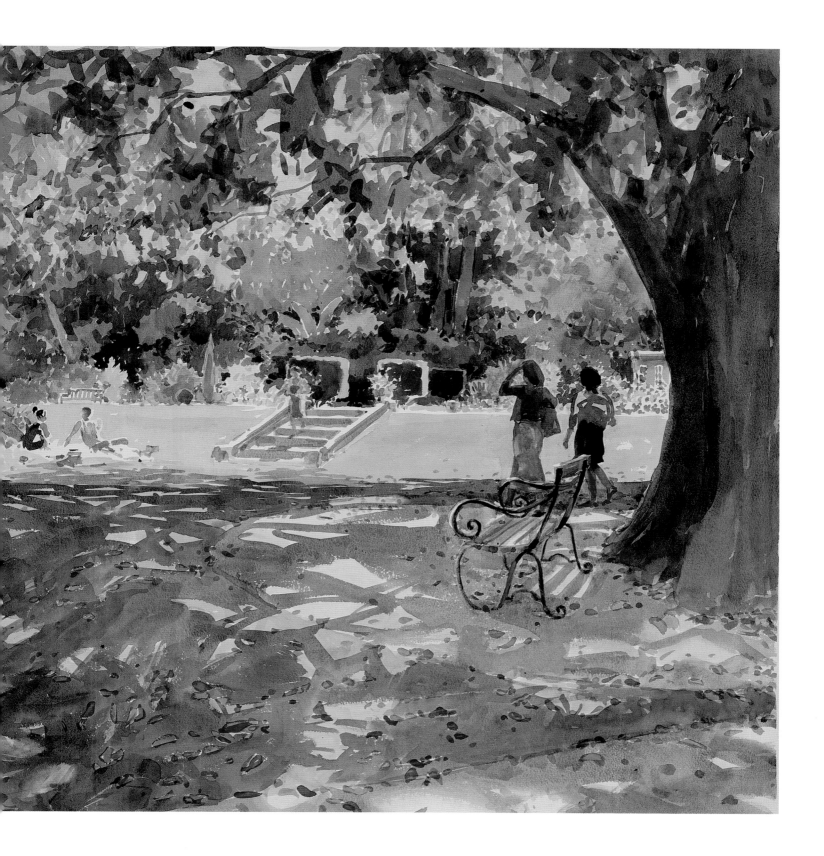

# Themes and variations

Having explored the technical and practical issues facing a watercolourist, your next step is to look at not how, but what to paint. The versatility of the medium means that you can go almost anywhere, equipped with your pigments and your knowledge of essential techniques, and achieve an enormous range of rewarding results.

In this chapter you will find some of my own favourite painting themes. It is hard to define exactly what makes someone want to paint a particular subject, but for me, as with many artists, it is often the effects of light and shade, which can make for a painting motif where you may least have expected one. Whether you are going to travel the world or stay at home and paint, there are ideas in the following pages to help you choose your subjects and develop your working method.

*Reflections, Shanghai, China*
43 x 56 cm (17 x 22 in)

# Landscape and countryside

As we have seen in previous chapters, landscapes are inevitably influenced by the weather and the light. The very term 'landscape' suggests a view which takes in a wide sweep. To decide on a composition, you need to consider various factors: where to place the horizon; how much of the scene to include; and how to resolve the often tricky problem of the foreground.

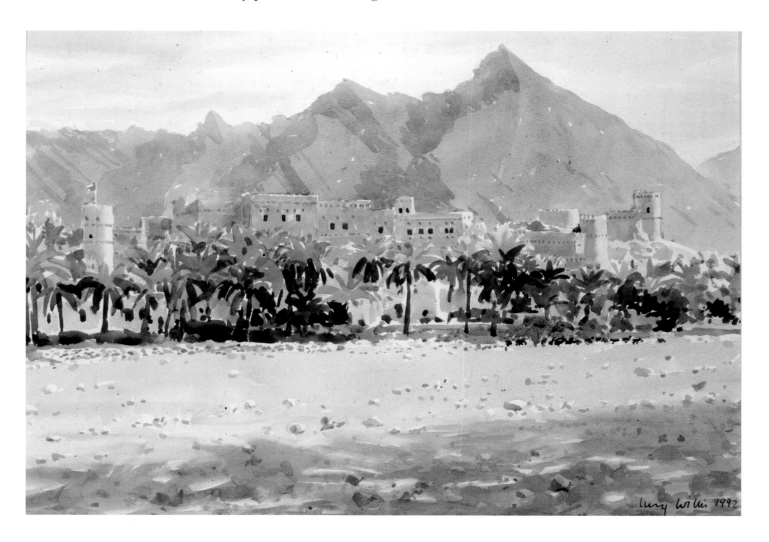

*Rustaq Fort under the Green Mountain, Oman* 43 x 64 cm  (17 x 25 in)
The fort itself is only just visible as the mountain behind is roughly the same tone. It was the subtle colour differences that made it such an intriguing image for me to paint. By throwing a shadow across the foreground I brought the space forward and so made the fort appear even more distant.

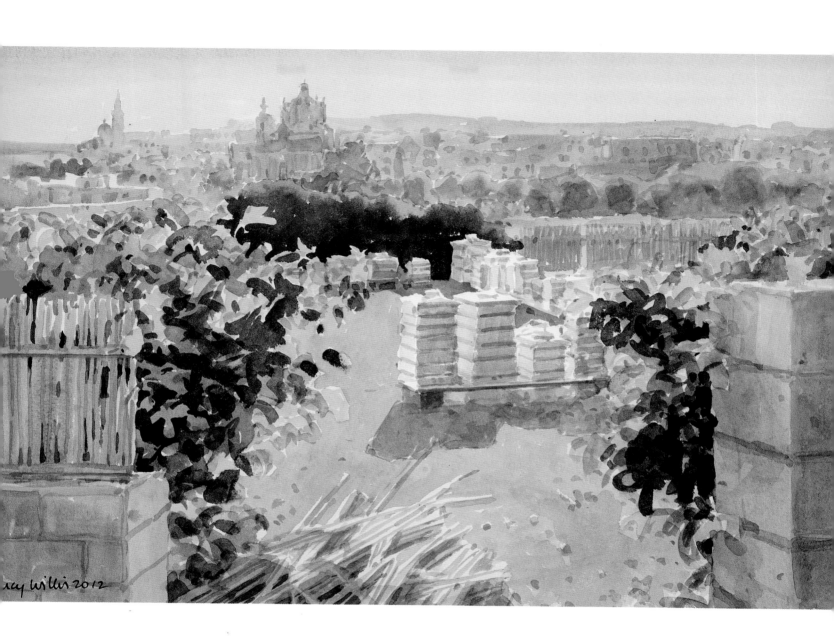

*Beehives, Gozo, Malta* 31 x 50 cm (12¼ x 19¾ in)

The strong blue shadows and warm reflected light on the beehives made a useful contrast with the distant view of soft-toned buildings. I have placed the horizon high on the paper so I could devote the rest of the painting to the interest in the foreground. The wall and near foliage looming large increase the sense of distance beyond.

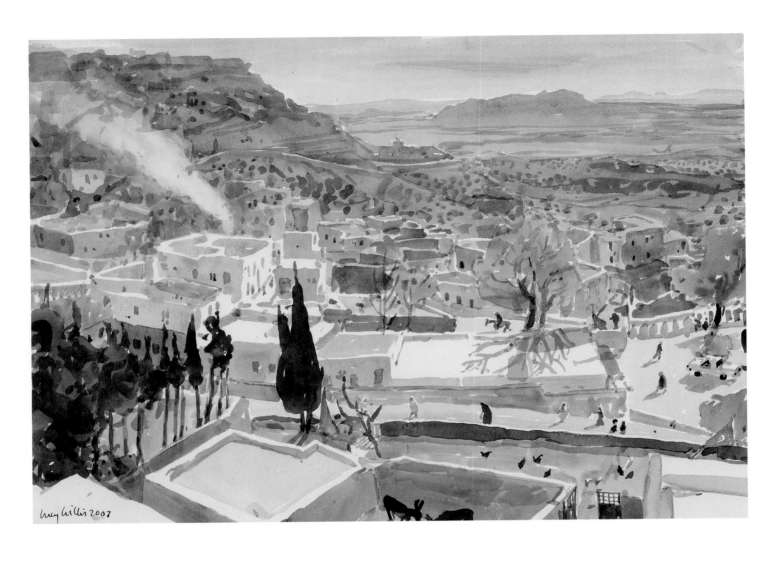

*Berber Village in the Mountains, Tunisia* 42 x 60 cm (16½ x 23½ in)

The sun was in front of me when I started but slightly to the right of me by the end of my painting session.
I added all the little shadows of figures and trees at the very end so they would fall in the same direction.

*The Lefka Ori, Crete, Greece* 38 x 28 cm (15 x 11 in)

Looking down on this steep valley from above, I placed the jagged skyline at the very top of the paper to increase the vertiginous effect. From the vast, mountainous panorama before me I chose to concentrate on the section of the scene which contained the most interest: the road and little homesteads.

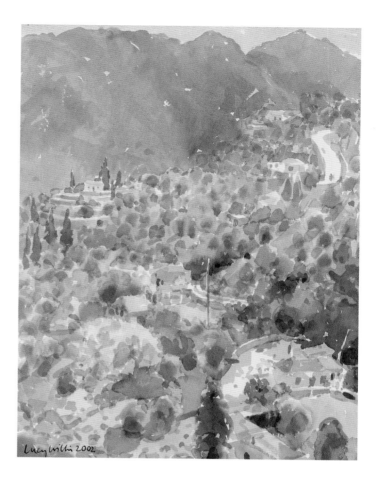

*Across the Xaghra Valley, Gozo, Malta* 17 x 38 cm (6½ x 15 in)

I managed to paint this little landscape from a bus shelter during a shower of rain. In spite of the weather there was a lovely soft light which emerged in the distance as the rain passed.

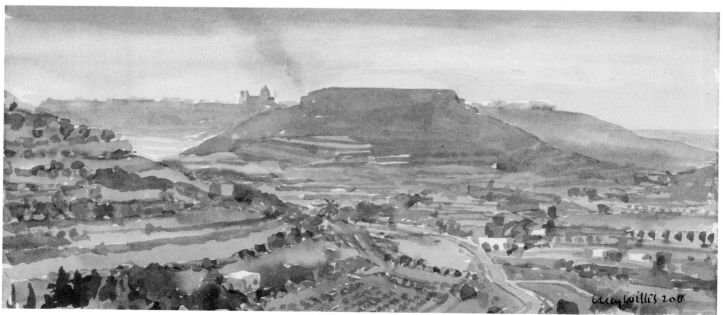

*Guilin River, China*
38 x 56 cm (15 x 22 in)

I painted this view from a restaurant, high above the river. The still surface of the water of the river was busy with boats and people, so I had to weave the mirror-like reflections of the striking karst mountains carefully among these scattered elements on the surface.

# Rivers and the sea

Painting water from nature in any medium is a challenge, but especially so in watercolour. All the paintings in this section have been done on the spot, or in the case of *Evening by the Sea* (see p.103), from a small observational sketch. I have found that the best way to represent water is to look very closely at the reflections and analyze the way that shapes of light and dark form, mutate and repeat themselves. Still water presents a different set of problems to flowing rivers and rapid torrents, but the same analysis will help in all cases.

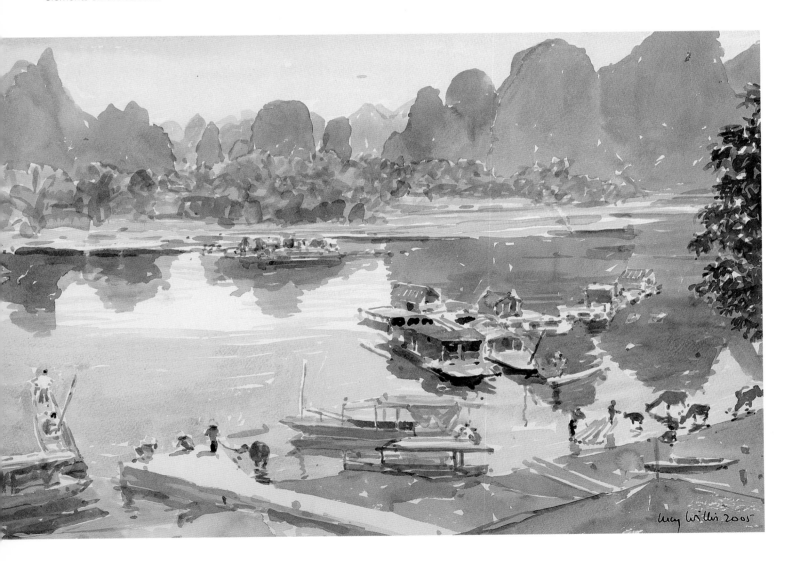

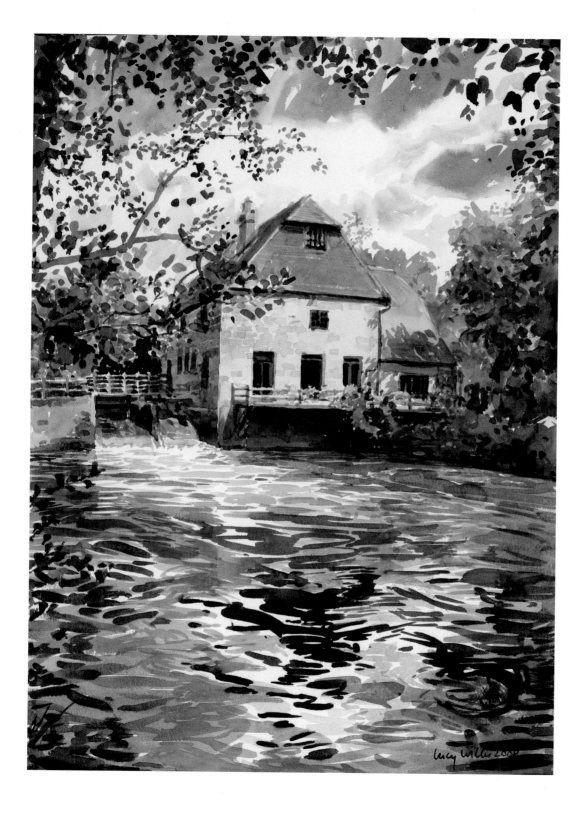

**The Sussex Mill, England**
56 x 38 cm (22 x 15 in)
Although the water here was agitated by the weir the patterns of reflection were repeated over and over again. The variety of greens in the foliage and water were mostly mixed from Sap Green, Prussian Blue and Winsor Violet, with variations on grey in the sky and water.

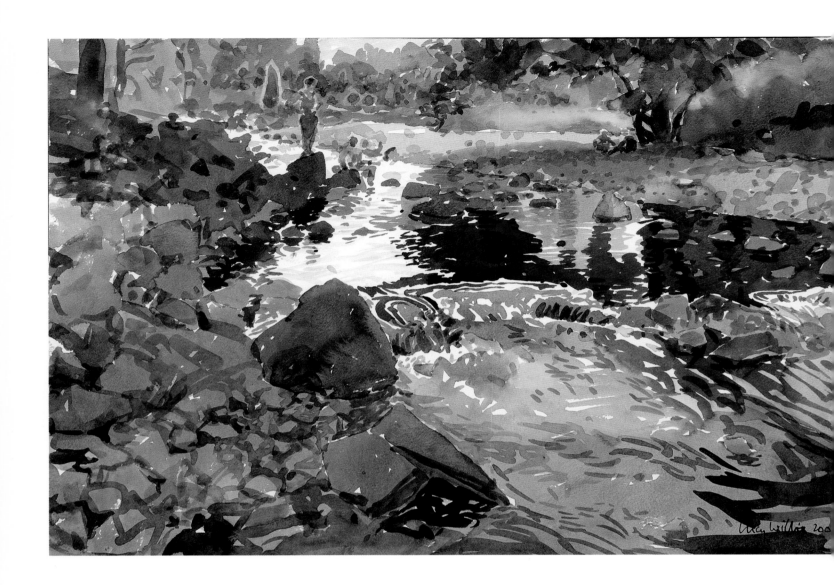

*The River Lussa, Mull, Scotland* 38 x 56 cm (15 x 22 in)

Analyzing the tones and shapes of the peat-brown reflections helped me to represent the difference between smooth-flowing water and the rapids in the foreground.

*Evening by the Sea, Sicily, Italy (pen sketch)*

Sitting on the beach after an evening swim, I made a little pen sketch of figures against the light.

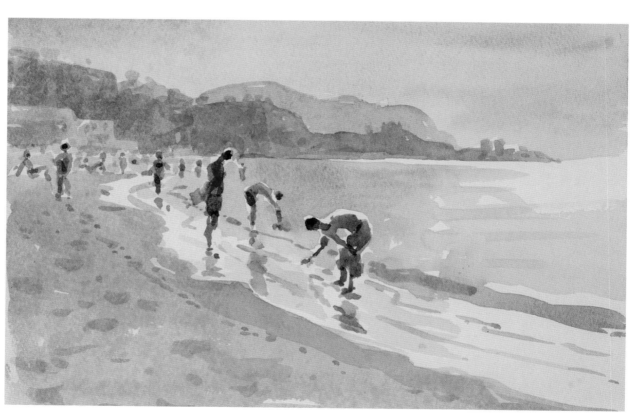

*Evening by the Sea, Sicily, Italy* 21 x 29 cm (8½ x 11½ in)

Once I was back in my hotel room I immediately did this watercolour from the sketch while the colours and the sun on the water were still fresh in my mind.

# Gardens and foliage

Painting gardens is very much like other types of landscape painting but in a more intimate setting. There can be few more pleasurable occupations than sitting in a garden, whether wild and rambling or tidy and well-clipped, on a warm summer's day. You may also enjoy wrapping up warm and dashing out to catch the frost or snow on the lawn in winter. The garden presents a space, contained and divided, in which a number of elements can come together – foliage, flowers, paths or vegetables – and in which the sun and shade can play to delightful effect.

*Trespassing at Doe Green, England* 30 x 56 cm (12 x 22 in)
Dappled shade suffuses this painting. There are all kinds of patterns to study: angular shadows on the shaded sides of the building; oscillating dapples on the front facets cast by the tree foliage; and endless variations of greens on the ground and in the trees and bushes.

*The White Bench, England*

28 x 38 cm (11 x 15 in)

Sap Green mixed with Winsor Violet results in a strong dark leaf colour which I have used for both the near left-hand foliage and the dark bushes beyond the figures. The vibrant, sunlit foliage is rendered with a mix of Lemon Yellow and just a touch of Sap Green.

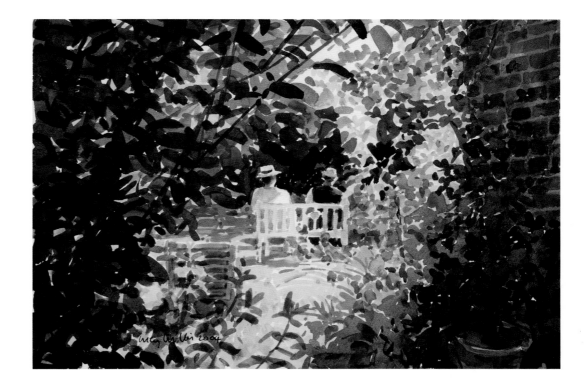

*Garden Bench in Winter, England*

28 x 38 cm (11 x 15 in)

It is the shadow here that anchors the bench to the ground and defines the plane of the pristine snow; it gives a strong sense of a winter sun, low in the sky, while the white of the paper becomes almost tangible snow.

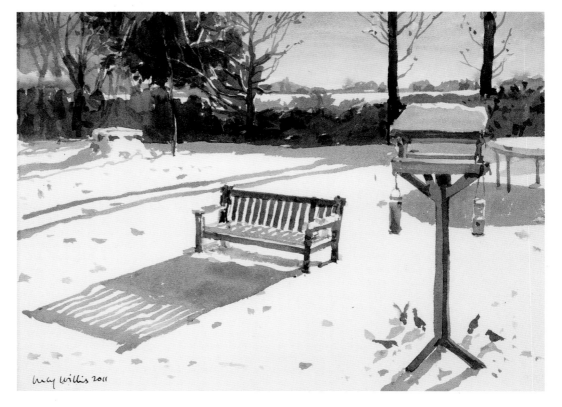

*Oxford Garden, England* 37 x 38 cm (14½ x 15 in)

Leaf patterns, shadow patterns and patterns of fabric and brick make a network of colour and tone.
By half-closing your eyes when faced with a confusing subject like this you can more easily sort out the
lights from the darks.

*Ruth's Garden in Summer, Greece* 41 x 60 cm (11½ x 23½ in)

I am always pleased to paint in hotter countries where there are fewer lawns and much less greenery than you will find in cooler, temperate climates. The foreground shadow has a glow of warmer colour within the cool grey. When the shadow wash was completely dry, I added the pinkish cement pattern between the paving stones.

# Buildings and townscapes

Once you attune your eye to looking for the effects of light and shade you will begin to see material for paintings everywhere around you. This can apply as much in the town as it does in the country. Before I painted *Back Street, Damascus* I was wandering around with my painting equipment, looking for a composition for quite some time. Then I saw this narrow alley. I was immediately drawn to the makeshift awning but it was the glow of light in the distance that made the potential for a picture. It is not always the most immediately attractive spot that makes the best painting.

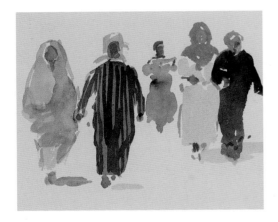

*Watercolour figure studies, Tunisia.*

*Back Street, Damascus, Syria* 38 x 30 (15 x 12 in)
Although the street was in dark shadow, the buildings above caught the last rays of afternoon sun and at the far end of the street the evening light was reflected by the yellow buildings, giving a strong, warm glow. As the painting progressed I deepened the foreground and side shadows again and again, using cool blues, violets and yellow ochre mixes, until I achieved the desired effect: a contrast between cool dark shadow and the warm, sunlit distance.

**The Judas Tree, London**
57 x 38 cm (22½ x 15 in)
Everything, from the brick
wall to the house behind, is
scribbled over with the shadows
of spindly winter branches.
I enjoyed untangling and
analyzing the patterns of dark
shadows, which I painted with a
brush, and the gate and fence
patterns. I drew these with wax
resist crayons and then washed
them over with paint, leaving a
light design against dark.

*Notting Hill Sunday, London, England* 28 x 38 cm (11 x 15 in)

White buildings in shadow make a perfect backdrop for a bright autumnal tree. Leaving white spaces for the bright, translucent yellow leaves, I drew in the shapes of the building behind with my brush. Gradually I filled in the bright yellow dots and worked on putting more colour of the buildings behind in the remaining spaces.

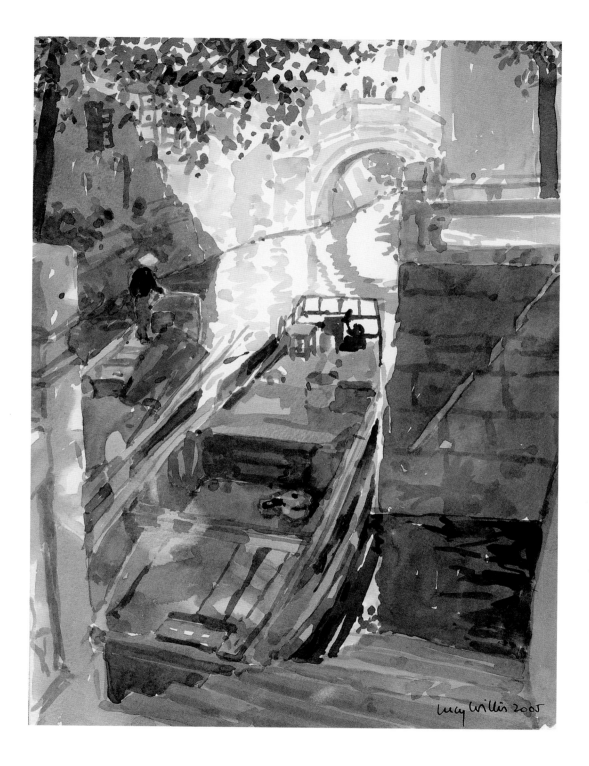

*Shrimping Boats, Mudu, China*
37 x 28 cm (14½ x 11 in)
This subject presented a wonderfully complex series of challenges: interesting angles and perspectives, dappled shade from an overhanging tree, bright sunlight in the distance and reflections in the water. My choice of viewpoint was largely driven by the convenience of being able to sit in shade at the top of the steps.

# Interiors and doorways

Whether it is your own home, where you are familiar with every corner, or in a place you are visiting for the first time, the challenges of painting interiors are often the same. Good drawing skills are essential so that you can create a convincing sense of space in which the elements of your composition can be contained. When choosing a subject I am often drawn to the enticing view through a doorway, whether looking in or out. Become aware of sunlight and shadows in interior spaces and you will find a wealth of inspiring and varied material.

*Lurcher in the Hall, England*

56 x 76 cm (22 x 30 in)

By darkening the foreground more than once – the wood panels, the chest, the dog and floor – I increased the sense of strong light in the room beyond and the garden outside, glimpsed through the door on the left.

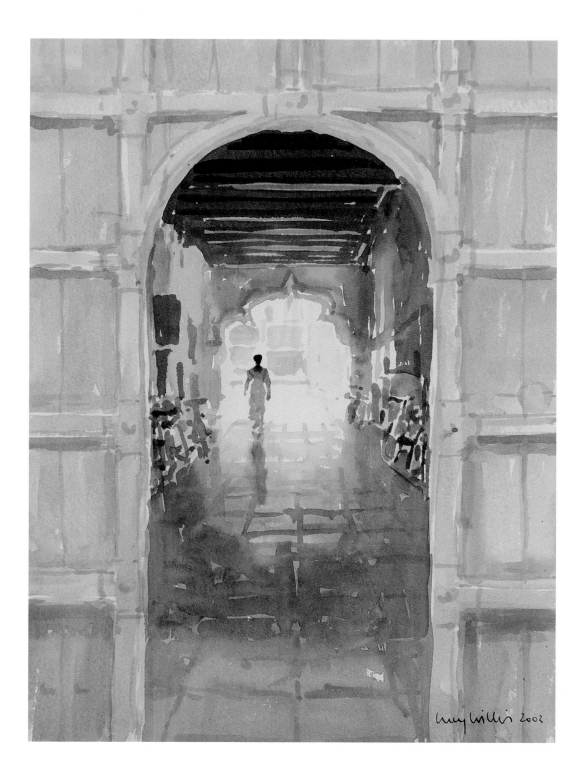

*Walking Towards the Light, Cochin, India* 38 x 28 cm (15 x 11 in)

Here is a glimpse of an interior through a doorway in the street. So often in India the passer-by gets a tantalizing peep into another world. The brightly lit courtyard beyond the figure is full of sunlight, creating the glow on the walls inside.

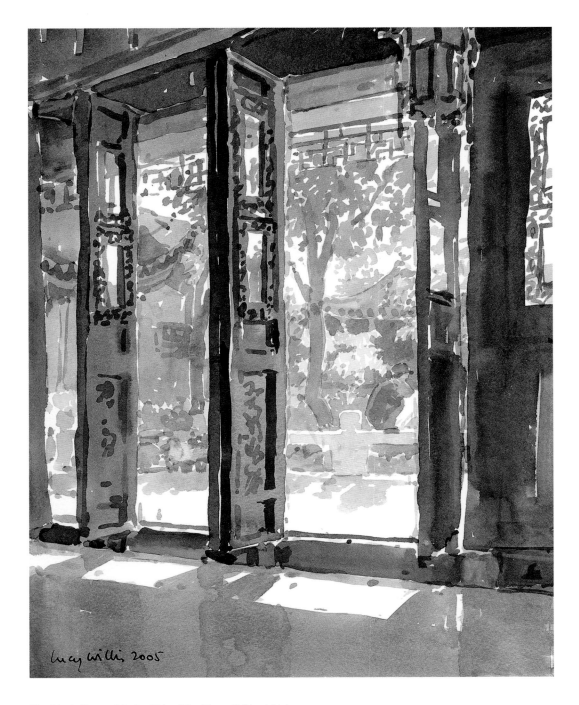

*The Music Room, Mudu, China* 37 x 28 cm (14½ x 11 in)
The many openings looking out to this Chinese garden gave an unusual structure to the composition.
I kept the tones of the outside view as light as I could in order to capture the sense that I was in a shady
interior looking out on a sunny day.

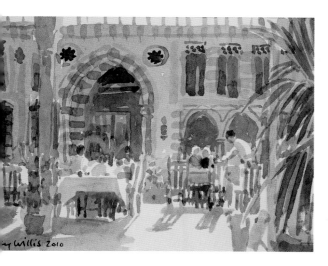

*Breakfast in Hama, Syria* 14 x 19 cm (5½ x 7½ in)

I painted this quick study while hotel guests finished their breakfast, bathed in sunlight. Knowing time would be short, I simplified the architecture and loosely defined the windows, doors and arches without worrying too much about strict accuracy.

*Santa Maria della Salute, Venice, Italy*

34.5 x 19.5 cm (13½ x 7¾ in)

Cool, dark, marble interiors such as this come alive when the sun comes in, creating a glow of warmth from the outside world.

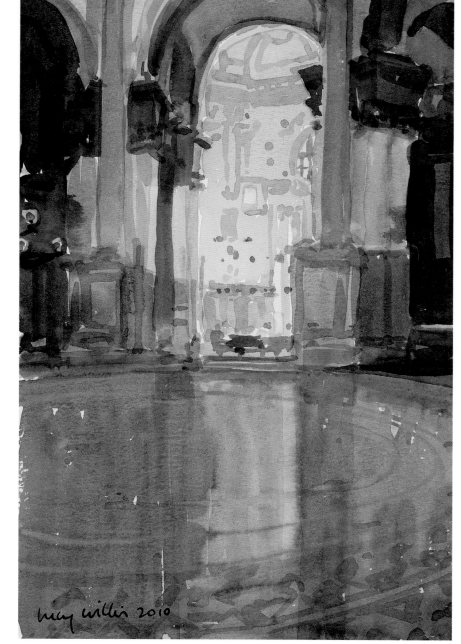

# Still life and flowers

A few objects on a table combined with light from a window can give you an infinite supply of attractive material to which you can apply your watercolour technique. There is no need to assemble a complicated set-up – it can be as simple as you like and still present rich effects and multiple challenges. By focusing your attention on the different types of shadows we have looked at in these chapters you will never be short of ideas.

A vase of flowers can be one of the most challenging of motifs but also one of the most delightful. My advice is to avoid too much detail and, while looking for the colour, don't forget to look for the light!

*Two Bouquets* 38 x 57 cm (15 x 22½ in)

Painting a background to a floral composition like this can be tricky. Starting the painting by getting the flowers and glass vases more or less in place, I then mixed plenty of background colour. I began my wash on the left, and carefully laid on a continuous dark tone around the flowers until I reached the right of the picture. Then I paused for breath before going back to fill the small spaces between flowers I may have missed and to finish the flowers with a bit more detail.

**Peaches on a Plate** 35 x 56 cm (13¾ in x 22 in)
With daylight filtering in from a north-facing
window, the only thing that appeared really bright
was the reflection of the light in the glazed white
plate. To get this shiny effect I had to tone down
everything else in the painting and leave the white
reflections with crisp edges.

**Raspberries in a Jam Jar** 28 x 19 cm (11 x 7½ in)
Painting a still life in direct sunlight has to be
done swiftly as the sun will move and change the
composition. The cast shadows here have hard-
edged clear shapes and the leaves glow with the
sun shining through them. I used Lemon Yellow with
a tiny touch of Cerulean Blue, painted very pale to
contrast with the darker leaves.

*Yellow Bowl with Geraniums*
41 x 52 cm (20½ x 16 in)
The brilliant colour of flowers
is often hard to capture and
trying to get that singing
vibrancy with mere paint
can be disappointing. Here
the Cadmium Red of the
geraniums is heightened by the
juxtaposition of bright blue – a
mixture of Cobalt and Cerulean.

*Pomegranate in a Bowl* 38 x 57 cm (15 x 22½ in)

This is a simple set-up but one which offers numerous challenges. Note the variations in tone in the shadow under the bowl and the reflections of the light on the striped oilcloth.

*The Bethnal Green Jug*
23 x 33 cm (9 x 13 in)

Try arranging a selection of white or near-white objects on a white surface and you will see how much variation in colour and tone there is. I have taken care to reserve some spots of white paper wherever I saw a highlight.

# Figures and portraits

If you are going to put people in your pictures it is important to be confident in your technique for painting them. Many a fine watercolour is let down because the artist has gone into a tight and detailed style when painting the figures, anxious to get them right.

Painting a portrait, on the other hand, may require many small changes of shape and proportion within the face in order to achieve a likeness. If this is your aim, rather than to make a study of an anonymous character, you will have to work with care; if too many changes are made to a watercolour the picture can become laboured and the surface messy and dull. But watercolour, being so suitable for rendering the glow and translucence of flesh, is one of loveliest mediums with which to paint a portrait if these technical difficulties can be overcome.

*People of Aleppo, Syria*
21 x 28 cm (8½ x 11 in)
I sat in the square and painted little studies of people as they came and went. I started with a flesh colour to place heads and hands, then added body shapes by painting clothes in varying colours. Later I put in the background shadows in sections to suggest sunlight on the ground and tie the whole page together. Figure studies such as these can be used for reference when adding people to another painting but make sure that they are subjected to the same light and shade as the rest of the composition.

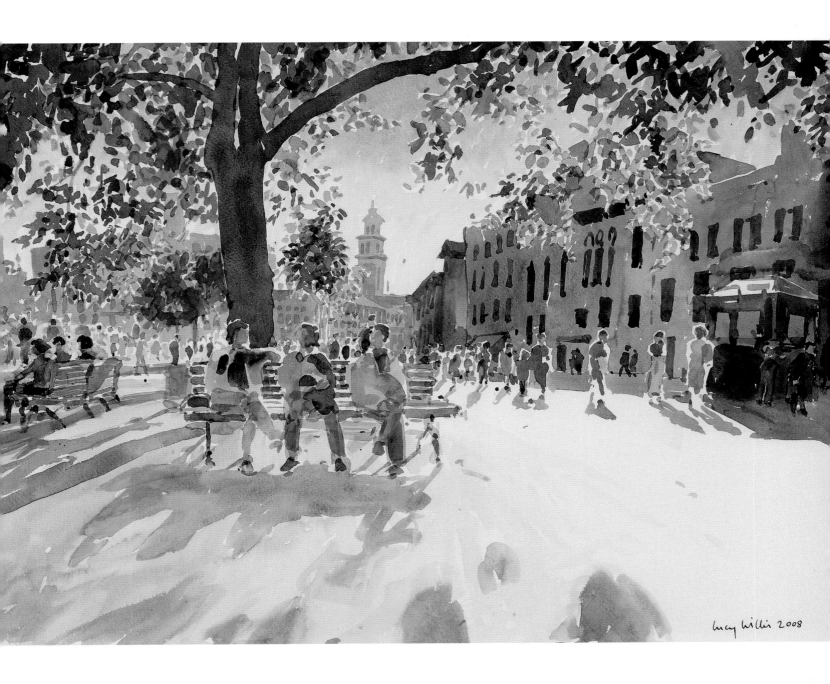

*Campo di Santa Margherita, Venice, Italy* 43 x 60 cm  (17 x 23½ in)

The women on the bench were sitting there when I started my painting so, having chosen my subject, I painted their basic shapes and plotted their shadows before they moved away. As the square was teeming with distant people too I had to put them in place before painting the buildings behind.

***Mother and Child by the Sea, Greece*** 18 x 21 cm (7 x 8½ in)

I captured the stance of the woman and the white hat of her baby as she stood still momentarily. Hours of practice on quick poses at the life class had stood me in good stead for this kind of rapid assessment of shapes and proportions. When she had gone I could add the other figures and trees and tie the whole thing together with directional shadows.

***Self-portrait, Portugal*** 30 x 42 cm (12 x 16½ in)

I did not attempt watercolour portraits until this early example of a self-portrait, frowning with concentration and dazzled by the sun, when I was 31. The intense sunlight bounced off the ground all around and lit my face from below. I darkened my forehead, the top of my nose and my cheeks until the sun really appeared to reflect on the different facets of my face.

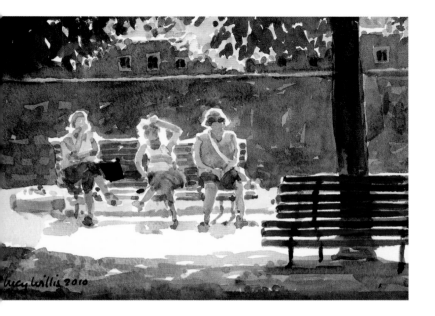

*Burano, Venice, Italy* 18 x 25 cm (7 x 10 in)

These figures were brightly lit from behind and set against a dark grey wall. To create the striking *contre-jour* effect I allowed halos of white paper around their hair and shoulders. I also left the ground white, thus adding to the impression of strong sunlight. From my position in the shade of the tree I could judge the tones without getting the sun in my eyes.

*Margaret and the Butterfly* 28 x 38 cm (11 x 15 in)

The shadow of the hat and the sunlight piercing through is what makes this such a charming but challenging subject. I had to be very careful not to make the shadow pattern dominate so much that the likeness was lost. As so often with a commissioned painting such as this, the likeness was key to the whole project.

*The Spider Tattoo* 40 x 35 cm (15¾ x 13¾ in)

Here my model is lit from the left by cool light from a window and from the right by the warm electric light
in the room. This made for striking contrasts and gave rise to a range of colours in the shadows on his face.
I used mixtures of yellow and red in the light parts of the face as well as blues and mauves in the darker areas.

*Berber Elder, Tunisia*

25 x 16 cm (10 x 6¼ in)

I made several quick studies where I was not too concerned with the exact likeness but more with capturing the character of my sitter. I worked with a close range of colours made from my usual reds, yellows and blues (see p.36), mixed to give a variety of browns and greys.

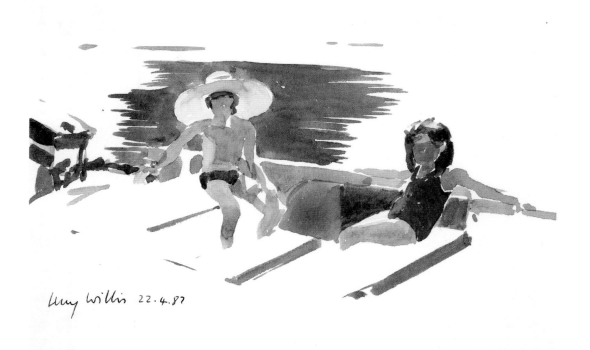

*Charlie and Sarah in a Boat, Portugal*

15 x 27 cm (6 x 11 in)

Looking for shapes of sunlight and shadow rather than detail, this early watercolour study somehow captures the likeness of my children.

# Index

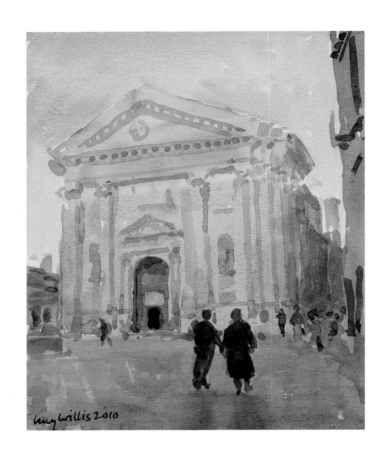

*San Barnaba Church, Venice, Italy*
22 x 18 cm (8¾ x 7 in)